T0303519

CELEBRATING GLOUCESTER

PAUL JAMES

AMBERLEY

First published 2023

Amberley Publishing, The Hill, Stroud
Gloucestershire GL5 4EP

www.amberley-books.com

British Library Cataloguing in Publication Data.
A catalogue record for this book is available from the British Library.

ISBN 978 1 3981 1457 9 (print)
ISBN 978 1 3981 1458 6 (ebook)

Typesetting by SJmagic DESIGN SERVICES, India.
Printed in Great Britain.

Contents

Introduction

Gloucester holds a very special place in the story of our country, spanning nearly 2,000 years, and has a special legacy of nationally significant events across all historic periods. It has seen invasions, civil wars, and sieges, it has both crowned a king and buried a king, hosted Parliament and has been the focus of great industry and innovation.

Gloucester is a city proud of its past and ambitious for its future. It is friendly, welcoming, tolerant and embraces its diversity. Although it has played an enormous role in influencing the course of our history over the centuries, it is a city that doesn't take itself too seriously. The city and its people are down to earth and unpretentious. They can be hard on their own city, perhaps borne out of a wish to see the place improve, but at the same time can be fiercely protective of it should anyone from outside dare to criticise it. Over time the city has faced many challenges, from the Siege of Gloucester in 1643 to major floods in 1947 and 2007, but has always shown great resilience, bounced back and moved on.

Gloucester is a growing city. At the latest count, its population has risen to 132,500. Its influence extends beyond the City Council's administrative boundaries, with adjoining suburbs and surrounding towns and villages looking to Gloucester as their city too – for services, shopping, entertainment and more. Much of its growth over the last few decades has been through new suburbs like Abbeydale and Abbeymead. In the south of the city, Quedgeley – which was a village but now has its own Town Council – has grown significantly including the new development at Kingsway on the site of the former RAF Quedgeley.

Gloucester is a city which cannot be taken for granted. Despite a long history of royal connections, which are covered in more detail later in this book, Gloucester sided with Cromwell's Parliamentarian army during the English Civil War. Political control of the City Council and who represents Gloucester in Parliament has swung back and forth between the two main parties over the years, although some of the city's MPs have served for a long time. The longest-serving MP in recent years was Sally (now Baroness) Oppenheim-Barnes, who represented the city between 1970 and 1987. The City Council was controlled by either Labour or a combination of Labour and the Liberal Democrats between 1989 and 2004, but has been run by the Conservatives since then, until the time of writing.

Gloucester could be seen as a city of contrasts. It is a city with numerous royal connections which backed the Parliamentarians when, literally, push came

to shove. It is a city with a Christian heritage of an abbey (now its cathedral), several priories and many churches, which now celebrates its ethnic and religious diversity. It is a city with many fine buildings but also others, mainly from the 1960s and 1970s, which we now look back on and wish they had not been built.

Gloucester is a city of characters. Over the centuries there certainly have been some interesting figures who hail from the area. Robert Raikes, whose Sunday school movement is seen as the precursor to today's system of state education, still features heavily in the city. The font in which he was baptised is still on display at St Mary de Crypt in Southgate Street. Opposite the church is the Robert Raikes' House pub where Raikes published the 'Gloucester Journal'. Just around the corner in Longsmith Street is Ladybellegate House, where Raikes was born.

The Robert Raikes' House pub in Southgate Street, formerly the home of the founder of the Sunday school movement.

George Whitefield, who was born at the Bell Inn and preached his first sermon at St Mary de Crypt in Southgate Street, helped spread the 'Great Awakening' across the USA. Another is William Ernest Henley, whose poem 'Invictus' inspired Nelson Mandela during his years of incarceration, and was also the inspiration for Long John Silver in *Treasure Island*, having had his leg amputated due to tuberculosis. Button Gwinnett, who was born at Down Hatherley and whose father was curate at St Nicholas' Church in Westgate Street, was the second signatory to the US Declaration of Independence. His signature is one of the most valuable in the world, selling at auction for over $500,000. Modern-day characters include longstanding Town Crier Alan Myatt, celebrity chef Tom Kerridge and 'Adventureman', the serial world record holder and fundraiser Jamie McDonald.

St Nicholas Church in Westgate Street, where Button Gwinnett's father Samuel was curate.

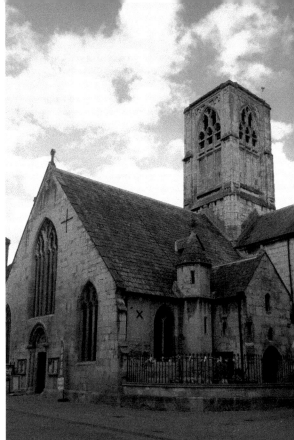

Above left: The Old Bell Inn in Southgate Street – the birthplace of George Whitefield.

Above right: St Mary de Crypt Church in Southgate Street.

The city is famously associated with the nursery rhyme 'Doctor Foster'. It has been suggested that the rhyme may be based on a story of Edward I of England travelling to Gloucester, falling off his horse into a puddle, and refusing to return to the city thereafter. Perhaps because of the unhappy ending, the only physical representation of Doctor Foster in the city is a waterside bar in the Kimberley Warehouse at Gloucester Docks, which bears the name.

It has also been suggested that another nursery rhyme, 'Humpty Dumpty', was based on a giant siege engine used by the Royalist forces during the siege of Gloucester in the English Civil War in 1643. However, other theories link the nursery rhyme to Colchester in Essex, as it's thought to be the name of a cannon that was used in that city during the English Civil War.

Many people say that Gloucester should make more of its rich history. In fact, it has such a rich heritage over many centuries that it is perhaps difficult to pinpoint the most important event, or even the most important period, in its history.

Is it the Romans? Gloucester, or its Roman name *Glevum*, was established around AD 60 at the first point where the River Severn can be easily crossed. As one of the decorative stones outside Gloucester Cathedral says, 'Gloucester exists

because of the River Severn'. For this reason, it's a shame the city doesn't make more of a feature of the river. Initially, a Roman fort was established at what we now know as Kingsholm to guard the river crossing. Later a larger fortress was built on slightly higher ground nearby, centred on the present-day Gloucester Cross, and a civilian settlement grew around it.

Gloucester became a Colonia (the highest status for a Roman city) in AD 97, known as *Colonia Nervia Glevensium,* or *Glevum,* in the reign of Emperor Nerva. A bronze statue of Nerva can be seen in Southgate Street. It was put in place in 2002 following a project led by Gloucester Civic Trust. The statue is on the site of an earlier statue of Nerva, the remains of which were discovered during an excavation.

Around AD 75, the Roman army moved on but the site of the fort was turned into a town for retired soldiers. Remains of the Roman city walls can still be seen at the Eastgate Viewing Chamber near the junction of Eastgate Street and Brunswick Road, inside the Museum of Gloucester in Brunswick Road and at the furniture store on the corner of Southgate Street and Parliament Street. Public art follows the line of the Roman wall at Kimbrose Square and at the Greyfriars development on Brunswick Road.

Then there is the Anglo-Saxon period, when Gloucester was captured following the decisive Battle of Dyrham in 577. The Mercian king, Osric of Hwicce,

The River Severn, taken from Westgate Bridge, is 'the reason that Gloucester exists'.

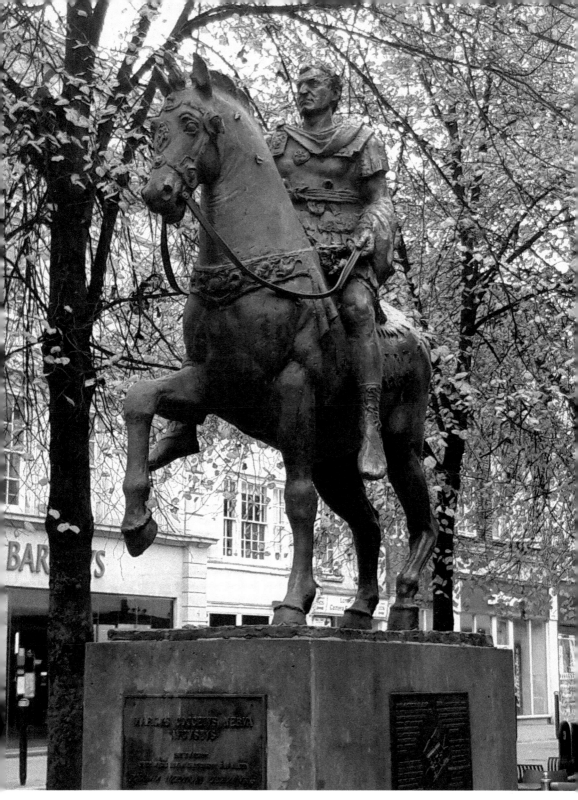

A statue of Emperor Nerva in Southgate Street.

Street art in Gloucester city centre which pays tribute to the city's Roman history.

founded an abbey dedicated to St Peter on the site of today's cathedral. By the tenth century, Gloucester continued to be an important centre in the Kingdom of Mercia, and was famously re-planned and re-fortified by Queen Aethelflaed as a defence against the marauding Danes.

Most people don't appreciate that, during the reign of Edward the Confessor, Gloucester was one of the three most important cities in England (the others were London and Winchester), with the King holding court here each year at Christmas. Following the Norman Conquest of 1066, William I continued to hold meetings in Gloucester, and on one such occasion in 1085, commissioned the most comprehensive survey of his new kingdom, the Domesday Book. There are different views as to which building was used to make this decision. Some contend that it was the Chapter House at what is now the cathedral, while others say it is more likely it was the royal palace at Kingsholm. Perhaps that's why there is little reference to it in the city.

The coronation of nine-year-old Henry III at St Peter's Abbey in 1216 – the last time the coronation of an English monarch has taken place outside of Westminster – doesn't get the profile it deserves. Neither does the burial of King Edward II just over a century later.

The burning at the stake of Bishop John Hooper in 1555 in St Mary's Square, near the cathedral, during the reign of Queen Mary would be front and centre in most towns and cities. It's true that a fine monument exists in his memory, but the story almost gets lost amongst the many others of national significance.

There is little left to see of Gloucester's former royal castle – and what does exist is hidden behind the walls of the former prison, for the moment at least. There's even less to show that Westgate Street was the site of a royal mint for almost 400 years. More on both of those in the chapter on royal connections.

Gloucester's significance in the Middle Ages is underlined by the fact that it had a number of monastic establishments – not just St Peter's Abbey (later Gloucester Cathedral), but also St Oswald's Priory, Llanthony Secunda Priory, Greyfriars and Blackfriars as well as some very early churches including St Mary de Lode Church, near the cathedral, and St Mary de Crypt, in Southgate Street.

Bishop Hooper's Monument, just outside the cathedral precincts.

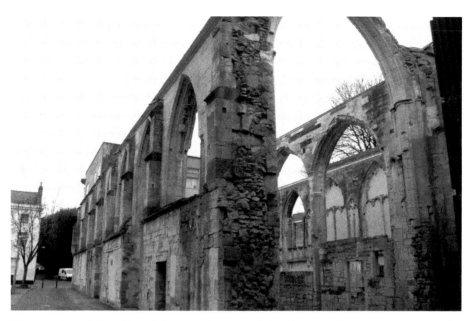

The remains of Greyfriars Priory at the rear of the Eastgate Shopping Centre. (Colin Organ)

Another important period in Gloucester's history began in 1378, when Richard II convened Parliament in the city. Parliaments were held there until 1406 under Henry IV. The Parliament Rooms at the cathedral remain as testimony to this important time. The Statute of Gloucester under Edward I was crucial to the development of English law.

More than once, Gloucester has changed the course of England's history, most famously during the Siege of Gloucester which took place between 10 August and 5 September 1643 during the First English Civil War, which many say was the city's finest hour. The city, under the governorship of twenty-three-year-old Lieutenant-Colonel Edward Massey, withstood the Royalists' attempts to bombard it into submission. Massey adopted an aggressive defence, even when the city was critically low on gunpowder, but held out until a Parliamentarian army led by the Earl of Essex arrived and forced King Charles I to lift the siege. Massey's headquarters during the siege were at the bottom of Westgate Street, where the Old Crown pub is now. Massey was elected MP for Gloucester in 1660 in the Convention Parliament and re-elected in 1661 in the Cavalier Parliament. After the Restoration, Massey switched sides and was knighted by King Charles II. He was offered the position of Governor of Jamaica, but never took up the post.

Much lesser-known is when, in 1471 during the Wars of the Roses, Gloucester closed its gates to the Lancastrian army headed by Queen Margaret of Anjou, wife of Henry VI. It did so on the orders of Richard, Duke of Gloucester, younger brother to the rival Yorkist King Edward IV. This was to prevent Margaret crossing

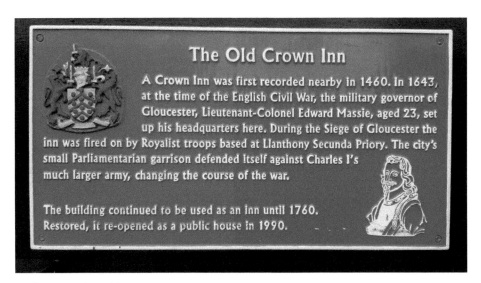

The Old Crown Inn

A Crown Inn was first recorded nearby in 1460. In 1643, at the time of the English Civil War, the military governor of Gloucester, Lieutenant-Colonel Edward Massie, aged 23, set up his headquarters here. During the Siege of Gloucester the inn was fired on by Royalist troops based at Llanthony Secunda Priory. The city's small Parliamentarian garrison defended itself against Charles I's much larger army, changing the course of the war.

The building continued to be used as an inn until 1760. Restored, it re-opened as a public house in 1990.

A plaque at The Old Crown Inn on Westgate Street.

the Severn and linking up with her powerful Welsh allies. Instead, she rode and marched her army from Gloucester to Tewkesbury, where it was routed in one of the decisive battles of the war. The Lancastrian heir to the throne, Edward, Prince of Wales, and many prominent Lancastrian noblemen were killed or executed and Margaret was captured. The rest, as they say, is history!

Over the years, Gloucester has had a rivalry with its near neighbour Cheltenham, with the ancient city viewing the more recently created town as upstarts and the latter looking down on Gloucester's more working-class population. After Gloucester's splurge of development in the 1960s and '70s, Cheltenham wondered whether it would ever catch up, but when Gloucester's progress stalled in the 1980s the spa town galloped ahead. These days, city and town have a more mature relationship which recognises their very different characters and assets. Gloucester has the cathedral, docks and top-flight rugby while Cheltenham has its regency splendour, festivals and horse racing.

Gloucester is a well-recognised name the world over. Gloucester UK is, of course, the 'original' Gloucester which has inspired other places to take its name in the US (Massachusetts, Virginia, New Jersey, Maine), Canada, Australia and even Sierra Leone. A project is underway to link schools in the various Gloucesters throughout the world, to learn from and about each other, with a particular focus on the environment. This project has been inspired by and received the backing of HRH The Duke of Gloucester.

Nowhere is the Gloucester brand more prominent than through its Premiership Rugby club, which is widely acknowledged to be one of the most passionately supported clubs in the country. The city comes alive on match days, with supporters wearing their shirts with pride. Although the club stopped using the city crest as its logo in the early 2000s because of issues over intellectual property

rights, one of its most recent shirts features elements of the city crest as a sign of its relationship with and pride in the city. Gloucester City FC's badge has also recently been updated to show features of the city – the cathedral, the docks warehouses and tall ships.

Single and Double Gloucester cheese are made from the milk of Gloucester cattle. The Single Gloucester cheese is used for the famous cheese-rolling event on nearby Cooper's Hill, which is known the world over and has been watched online many millions of times. Gloucester is also used in the name of many hundreds of businesses and organisations, from the Gloster Aircraft Company to the more modern-day Gloucester Quays Outlet Centre and Leisure Quarter. Another good example is Gloucester Brewery, which was launched in 2011 in the city's docks and has expanded its range of beers and gins and opened two bars in the city. Its recent crowdfunding exercise to finance further expansion hit its £500,000 target – backed by many people in the city, as much as an expression of pride and support for the place as it is confidence in the business.

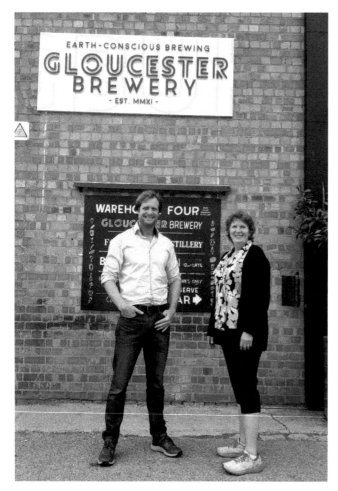

Jared Brown of Gloucester Brewery with Carol Steele, County Administrator from Gloucester County Virginia, who was visiting for Gloucester Day 2022.

Another high-profile use of the Gloucester brand are the motorway service areas known as 'Gloucester Services', which have northbound and southbound service areas located between junctions 11a and 12 of the M5. Run by independent operator Westmorland, who operate the Tebay Services in Cumbria, the service station shuns 'the big food chains' in favour of local artisan produce. The service area works with the Gloucestershire Gateway Trust to provide good jobs for the more deprived areas of Gloucester, and to support local social regeneration schemes.

Its 4,000-sqm. green roof was designed to disguise the new service station as part of the landscape as it has the Cotswolds on one side and Robinswood Hill on the other. It won the Civic Voice Design Awards in 2015 and television presenter Griff Rhys Jones, as President of Civic Voice, launched the 2016 awards from the northbound services in December 2015.

Another VIP visitor was former Prime Minister Liz Truss, who visited as Environment Secretary in February 2016. Gloucester MP Richard Graham, to howls of laughter in the House of Commons, promised her a 'warm welcome and a Gloucester Old Spot sausage' if she visited – something she described as 'one of the best offers (she) has had all year'. She later added that Gloucester Services was 'a brilliant example of promoting local food, bringing together local producers to something that is an amazing experience to all the visitors that come here'. Gloucester Services came top of a Which? survey ranking Britain's best and worst service stations in 2021.

One property developer said to me that Gloucester was an 'unpolished diamond'. As its regeneration programme works its way through the city, there's every chance that Gloucester will get its chance to sparkle in the future as it most certainly has in the past.

The Gloucester Services motorway service area on the M5.

Notable Buildings

Gloucester has many fine buildings. Indeed, it has one of the greatest concentrations of listed buildings outside London. In the city there are almost 500 listed buildings, thirty-six of which are of Grade I status. In addition, there are twenty-five scheduled monuments and fourteen conservation areas. According to figures quoted by Gloucester Civic Trust, some 153 listed buildings in the city were lost between 1950 and 1971. Thankfully, following the Trust's formation in 1972, very few have been lost since.

Gloucester Cathedral

Without doubt, Gloucester's most iconic building is its Norman cathedral, which is believed to be one of the finest buildings of its type in Europe. There are so many features of the cathedral that it is worthy of a book in its own right – and indeed many books have been written about it.

There has been Christian worship in this location since Osric, an Anglo-Saxon prince who founded a religious house in AD 678–9. At the time of the Norman Conquest, the monastery was not flourishing but in 1072, William the Conqueror appointed a monk from Mont St Michel in Normandy named Serlo who enthusiastically raised enough money to build the magnificent church we see today, starting in 1089.

The cloister of Gloucester Cathedral represents some of the most significant medieval architecture in the world, famed for its remarkable fan vaulting. This imaginative new style was developed here during the 1350s and the current cloister was finished by Abbot Froucester by 1412.

Originally built to house the monks, it provided a space for them to live, work and meditate. On the south walk of the cloister, there is a row of twenty niche-like spaces called 'carrels', which would have originally housed desks for the monks to study. Along the north walk there is the 'Lavatorium', a place for the monks to wash, which would have made use of a local stream.

More recently the cloisters have taken on another life as a popular filming location, most notably for a number of the *Harry Potter* films. A project got

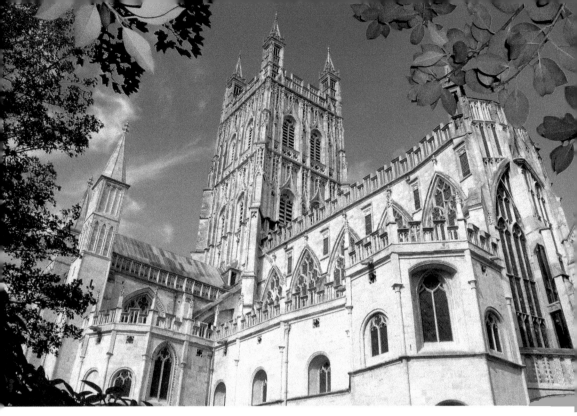

Above: Gloucester Cathedral – the city's finest building. (Colin Organ)

Below: Gloucester Cathedral's amazing cloisters. (Colin Organ)

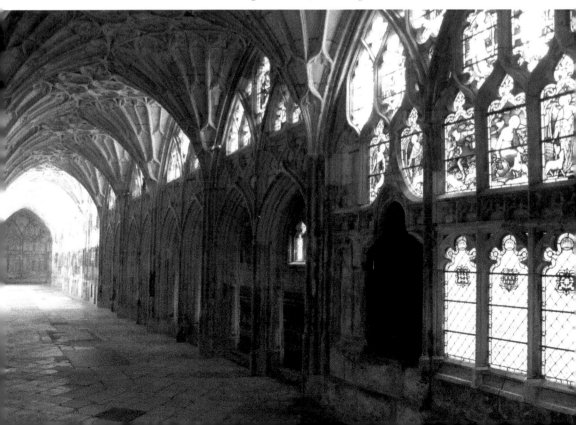

underway in 2022 to conserve the cloisters for future generations, putting right previous well-intentioned but ultimately detrimental repairs. A ten-year programme, it has been kickstarted by a remarkably generous donation of £550,000 from the Rausing family, who founded the Tetrapak empire.

The Great East Window was created as part of the rebuilding of the abbey church of St Peter. Built in the Perpendicular style, it was the largest window in Europe. It portrays the Coronation of the Virgin, surrounded by saints and angels. The glass mostly dates from the 1350s.

The east window is extremely large, measuring 72 feet high by 38 feet wide. It is the size of a tennis court and was the largest stained-glass window in fourteenth-century England. It has survived the Wars of the Roses, the Reformation, and even its removal into storage during the Second World War. More than three-quarters of the original glass is intact. During the Second World War, the glass from the east window was removed and stored in the crypt of the cathedral. The labels they had used on the glass got mixed up, so restorers after the war had to piece the window together using old black and white postcards to figure out where everything went. More than 150,000 cotton buds were used in a painstaking cleaning operation in 2003.

In another corner there appears to be a man in medieval yellow plus-fours playing what looks like an early version of golf. However, it predates the earliest known reference to the game by more than 100 years. It is believed, based on the size of the ball, that he may be playing a now obsolete game known as 'bandy' ball.

The cathedral's Parliament Rooms is an important place in both religious and political terms. The Parliament Rooms were part of a great hall used by Richard II to host Parliament in 1378. The Statute of Gloucester is a piece of legislation enacted in the during the reign of Edward I. The statute, proclaimed at Gloucester in August 1278, was crucial to the development of English law and were a means by which Edward I tried to recover regal authority that had been lost during the reign of his father, King Henry III.

Centuries earlier, a very important book was conceived when William the Conqueror held his Christmas Court in Gloucester. Edward the Confessor had established the practice, and the Norman kings followed suit, also indulging in a spot of seasonal hunting in the Forest of Dean. In 1085, William commissioned the compilation of the Domesday Book, and thus began the most remarkable census ever undertaken, creating a priceless record of medieval England.

King Henry VIII began the Dissolution of the Monasteries in January 1540. The abbey became Gloucester Cathedral and was no longer a community of monks. Under Oliver Cromwell, the cathedral came under consideration for demolition but the mayor and burgesses of the City of Gloucester intervened and saved the building.

The rare Mayor's Stall in the quire was added 1738 as a thanksgiving to the city for saving the cathedral during the Civil War. In recent years the Dean of the cathedral has officially 'installed' the mayor in their stall as part of the Annual Civic Services as a symbol of the strong partnership between the cathedral and the city.

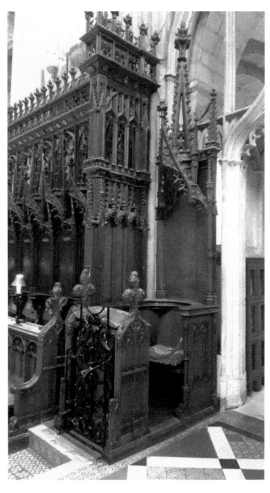

Right and below: The Mayor of Gloucester's special stall in the quire at Gloucester Cathedral.

In the 1770s, John Stafford Smith, the son of cathedral organist Martin Smith, composed the music for the Anacreontic Society's constitutional song entitled 'To Anacreon in Heaven'. 'The Star-Spangled Banner' was later set to the tune of 'Anacreon', as composed by Smith. The US Congress officially designated this song as the US national anthem in 1931. He has a memorial plaque in Gloucester Cathedral, above which are displayed the US and UK's flags.

The cathedral also houses three royal tombs. Firstly, King Osric who founded the abbey. The second burial is that of Robert Curthose, eldest son of William the Conqueror and brother of William II and Henry I. Robert inherited Normandy from his father, whilst the king gave England to his favourite son and namesake. Robert, eventually captured by his younger brother Henry I in 1106, was imprisoned for twenty-eight long years, where he died in his late eighties in Cardiff Castle in 1134. The third is King Edward II, whose burial is covered in detail in the chapter on royal connections.

For many years, the south side of the cathedral was covered with car parking. It wasn't until 2018 that under Project Pilgrim this was replaced with a new landscaped public space. This project was supported by the Heritage Lottery Fund and a number of other trusts and foundations. The same project also made all of the cathedral's ground floor accessible for the first time and improved the way in which the building's story is told with new interpretation.

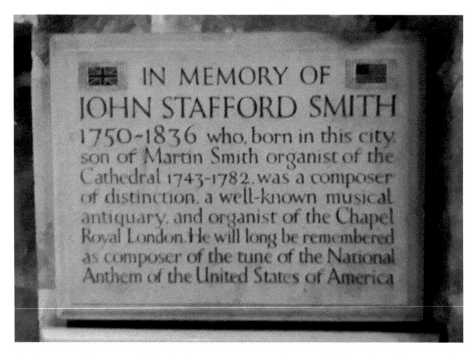

A plaque in Gloucester Cathedral commemorates John Stafford Smith, who wrote the music for the US national anthem.

As part of the Church of England's drive for sustainability, solar panels were fitted on the roof on the south side of the nave. This made Gloucester the first ancient cathedral, the oldest building in the country and the oldest cathedral in the world to have solar panels fitted. The panels were blessed live on local television by the Dean of Gloucester, the Very Reverend Stephen Lake.

Blackfriars Priory

Gloucester's Blackfriars, founded in 1239, is one of the most complete surviving Dominican friaries in England.

The monastery, known as Blackfriars from the black cloaks the friars wore, was founded on a site west of Southgate Street, with the city wall adjacent to the south, which had once been part of the Norman castle. It comprised a church and a quadrangle formed by buildings including the scriptorium (believed to be the first purpose-built library in England), the dormitory with its renowned scissor-braced roof and the cloisters. Henry III was a major benefactor of the friary, granting timber for the roof from the Forest of Dean and other royal forests. The former church is a Grade I listed building.

The friary went into private hands after the Dissolution of the Monasteries, having been purchased for £240 in 1539 by Thomas Bell, who converted the

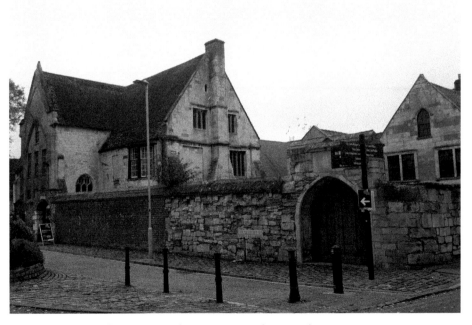

Blackfriars Priory, the most complete Dominican friary in the country.

church to his residence and transformed the buildings of the cloister, including the scriptorium, into a cap manufactory.

The cloister buildings were converted from a cap factory into dwellings in the eighteenth century and part of the west range was heightened and converted into three houses. In the 1930s Bell's mansion was converted into two dwellings. The ancient gateways onto the site had become known as Lady Bell's Gate, which is commemorated in the modern street name 'Ladybellegate'.

A painstaking restoration was undertaken by English Heritage from the 1960s until 1995, when it reopened to the public for occasional tours. In 2012 the site was leased to Gloucester City Council and is used for weddings, concerts, exhibitions, guided tours, filming, educational events and private hires.

Llanthony Secunda Priory

In 1136, after persistent attacks from the local Welsh population, the monks of Llanthony Priory in the Black Mountains of Wales retreated to Gloucester where they founded a secondary cell, called Llanthony Secunda. The new priory, a house of Augustinian canons, was situated around half a

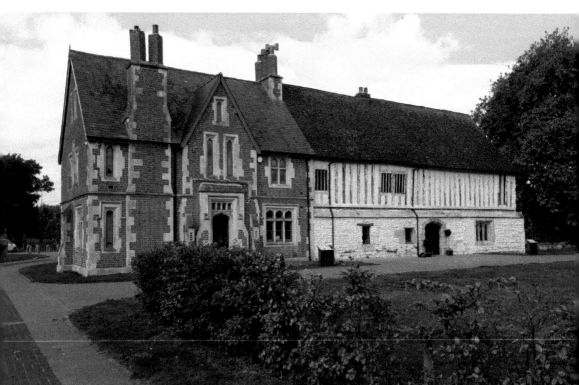

Llanthony Secunda Priory, alongside the canal at Hempsted.

mile south-west of Gloucester Castle in the parish of Hempsted. It was built on land gifted by Miles of Gloucester, the 1st Earl of Hereford, who was hereditary Constable of England and Sheriff of Gloucestershire, who resided at Gloucester Castle.

During the Siege of Gloucester, Llanthony was in Royalist hands. A cannon, shipped in from Holland to Bristol and from there to Gloucester, was placed on the walls of Llanthony Secunda and directed at Gloucester's city wall. Charles I hoped that this cannon would break the siege and win him control of the city. The cannon misfired and exploded on the first shot. Some believe this to be the origin of the Humpty Dumpty nursery rhyme, but this is disputed. The true origins of Humpty Dumpty are unknown but the idea that it refers to the Royalist cannon during the Siege of Gloucester is often cited as fact.

The priory church and cloister are long since gone and believed to be somewhere under the site of the adjacent Gloucestershire College campus. The building of the Gloucester to Sharpness Canal destroyed further elements of what remained.

The surviving remains of the priory were designated as Grade I listed in 1952 and the wider site is a scheduled ancient monument. The City Council acquired the priory in the 1970s and carried out some restoration works, but the site was still surrounded by an industrial wasteland. In 2007, a Trust was set up to bring out the full restoration of the buildings. In 2013, the Llanthony Secunda Priory Trust was awarded Heritage Lottery funding for restoration work, which was completed in August 2018 when it reopened to the public. It was later officially reopened by HRH The Duke of Gloucester.

26 Westgate Street

This rather unremarkable-looking building, today occupied by the Gloucester Antiques Centre, is described in the Historic England listing as 'one of the most substantial timber-framed merchants' houses to have survived in any English town'. It began life in the late fifteenth century, though it has since then been significantly enlarged. As was often the case for such distinguished timber-framed buildings, the Georgians replaced the facade with brick. The most impressive view, however, is from Maverdine Lane, a narrow medieval alley immediately to the side of the building. From here, if you look up you can see the building in its original Tudor timber-framed glory – although it is very difficult to capture its magnificence in a photograph!

As well as being a merchant's town house, it was for more than 100 years home to the seed merchants Winfields until they moved out in 1989. For many locals it is this use that stands out in the memory. In 2000, the building was used as a bookshop, then left empty for several years until the Gloucester Antiques Centre moved there in 2015.

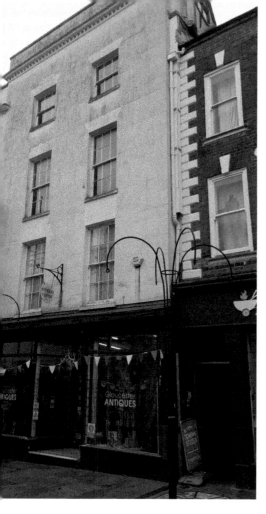

26 Westgate Street, a sixteenth-century merchant's house, now home to the Gloucester Antiques Centre.

Gloucester Guildhall

The Guildhall is a Grade II listed former civic building in Eastgate Street which is now used as an arts venue.

The original town hall, known as 'The Tolsey', meaning 'town hall', was a fifteenth-century building located on the corner of Westgate Street and Southgate Street. It was rebuilt in 1751 but had become too cramped for civic leaders by the late nineteenth century.

The site chosen for the new building had previously been occupied the Blue Coat School founded by Sir Thomas Rich, but had become vacant when the school moved to the site of the former Crypt School in Barton Street in 1889.

The new building, which was designed by George Hunt in the Renaissance style, was completed in 1892. King Edward VII visited the Guildhall on 23 June 1909 before attending the Royal Agricultural Show at the Oxleaze Showground on Alney Island. The Guildhall also received a visit from Queen Elizabeth II, accompanied by the Duke of Edinburgh, to celebrate the 800th anniversary of the granting of the city's charter by King Henry II, on 3 May 1955.

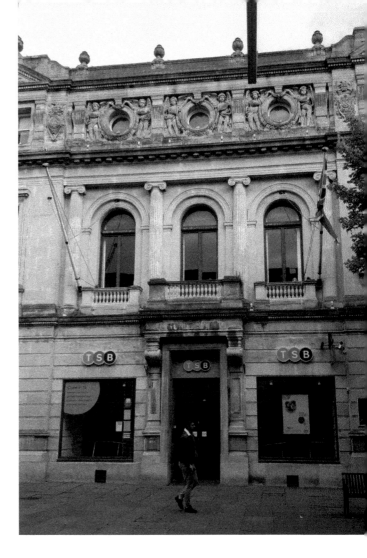

Gloucester Guildhall in
Eastgate Street.

For much of the twentieth century the Guildhall was the meeting place
of the county borough of Gloucester and continued to be the local seat of
government following the formation of the enlarged Gloucester City Council in
1974. However, in 1985, the council decided to move their headquarters and
meeting place to the restored North Warehouse at Gloucester Docks to kickstart
the regeneration of the docks area. The last City Council meeting at the Guildhall
was chaired by the then Mayor of Gloucester, Councillor Andrew Gravells.

The ground floor was converted into a branch of the Cheltenham & Gloucester
Building Society in 1987, which later evolved into a branch of TSB Bank. The
upper floors were retained by the council to use as an arts centre. The council
chamber was converted into a cinema with capacity to seat 100 people, while the
main hall is used for live music and other events. The rock band EMF recorded
a video of their first single, 'Unbelievable', which reached number 3 on the UK
Singles Chart, in the main hall one night in 1990. There is a gallery space, café bar,
studios and meeting rooms.

The New Inn

Found on Northgate Street is a timber-framed building used as a public house, hotel and restaurant. It is the most complete surviving example of a medieval courtyard inn with galleries in Britain, and is a Grade I listed building.

The inn was built in 1450 by John Twyning, a monk, as a hostelry for the former Benedictine Abbey of St Peter. It is on the site of an earlier inn. After the dissolution of St Peter's, the inn passed to the Dean and Chapter of Gloucester Cathedral and was leased to various inn holders until it was sold in 1858. It is said that the New Inn is one of the three 'Great Inns' of Gloucester that were built to provide lodgings for pilgrims to the tomb of King Edward II, along with the Fleece Hotel and The Ram Inn, in Northgate Street (which no longer exists).

In 1553, King Edward VI died and Lady Jane Grey was proclaimed Queen from the first-floor gallery by the Abbot of Gloucester – although this is disputed by historians who say that many proclamations would have taken place across the country, as was the case when Kings Charles III acceded to the throne in September 2022.

It is thought that William Shakespeare may have performed at the inn with his company The Lord Chamberlain's Men. The timber frame of the large three-storey

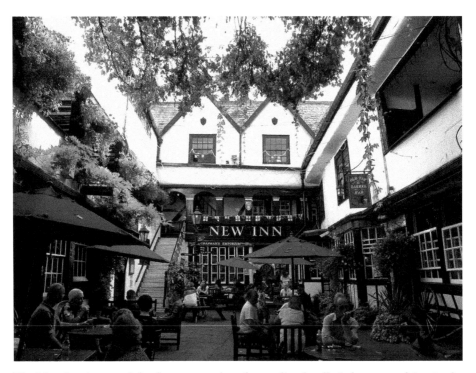

The New Inn is one of the finest examples of a medieval galleried courtyard inn in the country. (Colin Organ)

rectangular building is of oak with lathe and plaster-rendered panels. Open galleries overlook the courtyard and provide access to rooms on the upper floors.

The inn was acquired in the early 1990s by the Magic Pub Company, who carried out unauthorised works, including turning fifteen of the bedrooms into offices. They put the building up for sale in 1996 and, after having no serious offers, closed it in February 1998, before it was reopened by new owners in May of that year.

The Fleece Hotel

The Fleece Hotel, Westgate Street, is a timber-framed building dating from the fifteenth century which incorporates a twelfth-century stone undercroft – one of the finest examples in Europe. The building is part Grade I and part Grade II listed with Historic England.

The Fleece Hotel was first opened in 1497 as one of the three major inns of Gloucester to house pilgrims visiting the tomb of Edward II of England. The twelfth-century undercroft, known as the 'Monk's Retreat', was originally part of a merchant's house and was incorporated into the structure. By 1455, it was a property owned by Gloucester Abbey, and was developed into an inn by the abbey during the sixteenth century. It was first recorded as the Golden Fleece Inn in 1673. The building was made part Grade I listed in January 1952, with other parts of the building made Grade II listed in December 1998.

For many years, the hotel was run by several generations of the Rich family before the cost of required electrical works forced its closure in 2002. It was later

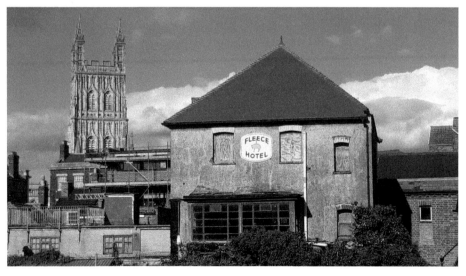

The historic former Fleece Hotel dates back over 500 years and is now awaiting regeneration.

acquired by the South West Regional Development Agency before being purchased by Gloucester City Council when the agency was wound up in 2011. Later that year, the council announced a £350,000 restoration scheme. They subsequently undertook waterproofing work in both the salt loft and the kitchen block, with further repair works and partial demolition afterwards.

In July 2017, the building suffered an arson attack which caused extensive damage, particularly to the roof of the Edwardian block.

In September 2019, Gloucester City Council announced that the site, along with the adjacent Longsmith Street multi-storey car park, would be redeveloped. The council was awarded £20 million from the government's Levelling Up Fund in October 2021, of which £6 million was believed to be allocated to The Fleece.

St Oswald's Priory

St Oswald's Priory was founded by Aethelflaed, daughter of Alfred the Great, and her husband Aethelred, Lord of the Mercians, in the late 880s or 890s. It appears to have been an exact copy of the Old Minster, Winchester, and is a Grade I listed building.

It was initially dedicated to St Peter, but in AD 909 the remains of St Oswald were seized from Bardney Abbey in Lincolnshire and brought to Gloucester. They were

St Oswald's Priory, which sits in the shadow of Gloucester Cathedral.

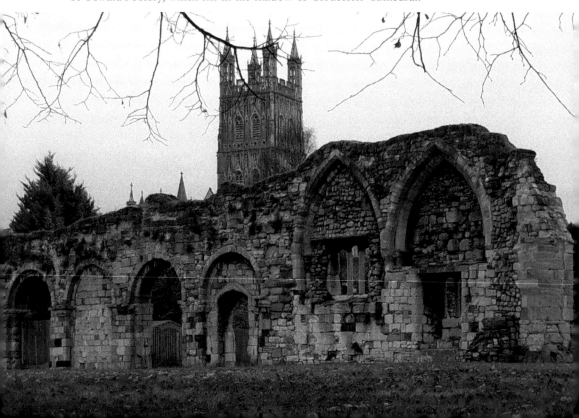

placed in the new minster church founded by Aethelflaed and the priory was renamed St Oswald's in his honour.

Aethelflaed died in June 918 in Tamworth and her body was brought to Gloucester and is believed to be buried at St Oswald's. Part of an intricately carved grave slab was discovered during an archaeological excavation in the 1970s and is believed to have been for Aethelflaed. It is on display at the Museum of Gloucester.

She was responsible for bringing together England as we know it today. She died in Tamworth and her body was carried 75 miles to Gloucester to be buried at St Oswald's Priory, which she founded. To mark the 1100th anniversary of her death, a statue was installed outside Tamworth railway station and her funeral was re-enacted in Gloucester, with her body (played by a local actress) being carried through the city centre streets.

Aethelflaed was also responsible for the street pattern in Gloucester city centre, much of which survives today. She features in Bernard Cornwell's 'Saxon Stories' series of books and the Netflix series *The Last Kingdom*.

From Norman times the importance of St Oswald's declined as the royal palace at Kingsholm was abandoned in favour of the newly built castle to the south-western corner of the town, and Abbott Serlo began an ambitious new church (later Gloucester Cathedral) to replace the old minster. The priory was finally dissolved by King Henry VIII in 1536. Part of the church was converted into the Parish Church of St Catharine before being largely destroyed by Royalist cannon fire during the English Civil War in 1643. The parish was then without a church until 1868 when a new one was built adjacent to the ruins. This was demolished in the early twentieth century and replaced with the current St Catharine's Church on London Road in 1915.

The House of the Tailor of Gloucester

This small building in College Court, next to St Michael's Gate, is what Beatrix Potter chose to sketch for *The Tailor of Gloucester*, which is said to be her favourite book. The story of the *Tailor of Gloucester* is based on a real-life character, John Prichard, who was commissioned to make a waistcoat for the Mayor of Gloucester to wear at his wedding, which was to take place on Christmas Day. The tailor returned to his shop on a Monday morning to find the suit completed except for one buttonhole. A note attached read, 'No more twist'. His assistants had finished the coat in the night, but Prichard encouraged a fiction that fairies had done the work and the incident became a local legend. In the story, the waistcoat is finished by the grateful mice the tailor rescues from his cat. Prichard's tailoring shop was in fact on Westgate Street, part of what is now called the Sword Inn – although at one point it was called The Tailor's House. Beatrix Potter, however, thought that 9 College Court was a more attractive building so she sketched it instead.

A shop and museum based on Beatrix Potter and her works was opened in 1979 by the publishing company Frederick Warne & Co. Inside, the tailor's kitchen has

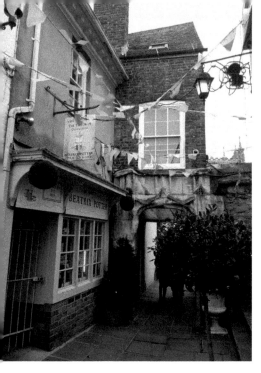

The House of the Tailor of Gloucester in College Court.

been recreated and there is a replica of the waistcoat made for the tailor, which was made from the wedding dress of Lady Carolyn Elwes, wife of former Lord Lieutenant Sir Henry Elwes.

Queen Elizabeth II was given a specially printed copy of the book, to mark 100 years since its publication, when she visited Gloucester Cathedral for the Maundy Service in 2003.

The shop closed in 2005 due to falling sales but reopened after a campaign led by local businessman Ivan Taylor raised enough money, by selling shares, to buy the building. It is now run by volunteers. A regular visitor to and supporter of the museum and shop over the years has been the actress Dame Patricia Routledge, who is best known for playing Hyacinth Bucket in the television sitcom *Keeping Up Appearances*, in her role as Patron of the Beatrix Potter Society. She played Beatrix Potter in the stage play *Beatrix* in 1997, and in 2016 she starred in the TV documentary *Beatrix Potter with Patricia Routledge*.

The Folk of Gloucester

The Folk of Gloucester, at 99–103 Westgate Street, is a heritage centre and former museum which is housed in some of the oldest buildings in the City of Gloucester. 99–101 Westgate Street is a Tudor merchant's house dating back to around 1500 and 103 Westgate Street, a seventeenth-century town house, was added around 150 years later. The museum, when under council control, was devoted to the social history of Gloucestershire. It now acts as the headquarters of the Civic Trust, hosting a wide range of events.

Bishop Hooper is said to have lodged in the buildings now occupied by the museum the night before he was burned at the stake in front of St Mary de Lode Church in 1555, although this is not certain. The building contains a stake believed to be from his burning.

In the eighteenth century it was a pin factory for Kirby Beard & Co. and thousands of pins are said to still lie underneath the floorboards!

The museum was for many years called Gloucester Folk Museum before rebranding itself in 2016 and then became the Gloucester Life Museum. It rebranded again in 2019, becoming The Folk of Gloucester, when the Gloucester Civic Trust took over the running of the building. Ownership was transferred to Gloucester Historic Buildings, a joint Civic Trust and City Council company, in 2021. The Civic Trust have started works to restore the building, beginning with works to the façade, including new, brightly coloured paint, which reflects how they would have looked in medieval times and the fact they are three separate buildings.

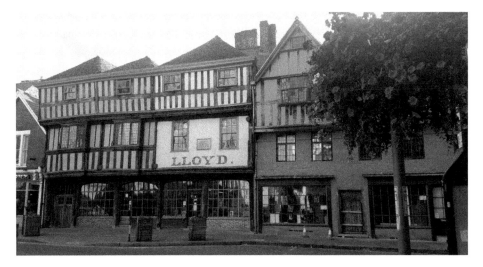

Above: The Folk of Gloucester in Westgate Street after a restoration of the façade in 2022.

Right: A bollard, in one of the pedestrianised streets in the city centre, in the style of a pin – as a nod to Gloucester's history of pin-making.

Post-war Regeneration

Gloucester's city centre saw a splurge of development in the 1960s and 1970s as an ambitious City Council sought to sweep away tired old buildings and replace them with more modern structures. The development was guided by the Jellicoe Plan, published in 1962, which was drawn up by the esteemed architect Sir Geoffrey Jellicoe.

The developments at the time included new shopping centres at Kings Walk and Eastgate, each with their own rooftop car parks. A new multi-storey car park was built at Longsmith Street and all three were linked by bridges across Eastgate and Southgate streets. Kings Square was created as a public space with fountains and underground toilets and was officially opened by Environment Secretary Peter Walker in May 1972. It went on to win a civic award.

At the time, Gloucester was seen as a go-ahead city and our neighbours in Cheltenham wondered whether they would ever catch up as a shopping destination. When we look back now, there are buildings which we wish hadn't been lost. Perhaps the most striking example is the Bell Hotel on Southgate Street, which closed in 1967. It was replaced by the brutalist concrete architecture of the Eastgate Shopping Centre. Another building lost was Southern Stores in Northgate Street, which led to the formation of Gloucester Civic Trust in 1972 in the role of guardians of the city's heritage.

After the developments of the 1960s and 1970s, little development of any scale took place in the city centre in the 1980s and 1990s, although the city grew through housebuilding in suburbs such as Quedgeley, Abbeydale and Abbeymead.

By the 1980s, Gloucester Docks was becoming a concern. It had ceased to function as a working port, losing out to road and rail, as well as to bigger ports which could accommodate larger vessels. There was even a suggestion that the Victoria basin should be filled in and built upon. The British Waterways Board had applied to demolish the derelict North Warehouse, but the City Council resisted. Eventually the council was persuaded to put its money where its mouth was and agreed to restore North Warehouse and convert it to a civic headquarters. The council also took on the Herbert, Kimberley and Phillpotts warehouses as offices. They paid for it by selling a lease on the ground floor of the Guildhall in

Eastgate Street to the Cheltenham & Gloucester Building Society. Staff were also relocated from the Treasury building in Lower Eastgate Street and Cedar House in Spa Road.

British Waterways agreed to bring the National Waterways Museum to the Llanthony Warehouse at the other end of the docks, with a two-pronged approach intended to act as a catalyst for the wider regeneration of the docks. It had limited success, with the opening of Doctor Fosters' pub, the building of the Merchants Quay shopping centre and the Victoria and Britannia Warehouse converted to offices. The Robert Opie Pack Age Museum occupied the Albert Warehouse. Economic recessions and planning battles between the developers and the City Council left the job unfinished.

At the same time, the council was seeking to regenerate the Blackfriars area of the city, which covered the area between Westgate Street, Southgate Street, the docks and the River Severn. There were plans for a large-scale retail development, with a department store and between forty and fifty smaller shops. The scheme collapsed when legal action by British Telecom led to the planning permission being quashed. This caused a great deal of scepticism amongst the population as to whether the regeneration of the city would ever be delivered.

The regenerated Gloucester Docks. (Colin Organ)

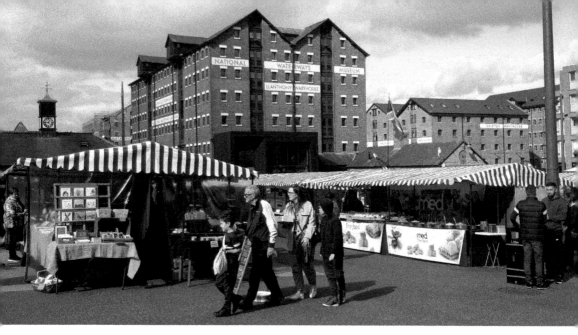

Orchard Square, in front of the National Waterways Museum at the Docks, is used for regular markets and events.

Fortunately, plans to regenerate the city's Cattle Market, which had been ravaged by the BSE and Foot and Mouth crises, gave Gloucester new hope. The livestock market itself closed in 2001 but developers Grantchester, who were later taken over by property giants Hammerson, built the retail park we know today, anchored by what was the biggest B&Q store in Western Europe.

Hot on the heels of the collapse of the Blackfriars scheme came proposals for Gloucester's largest ever regeneration project at Gloucester Quays, promoted by a partnership of Peel Holdings and British Waterways. The plans included an outlet shopping centre, supermarket, new further education campus, hotel and

St Oswald's Retail Park on the site of the former Cattle Market.

Above and right: The outlet shopping centre at Gloucester Quays.

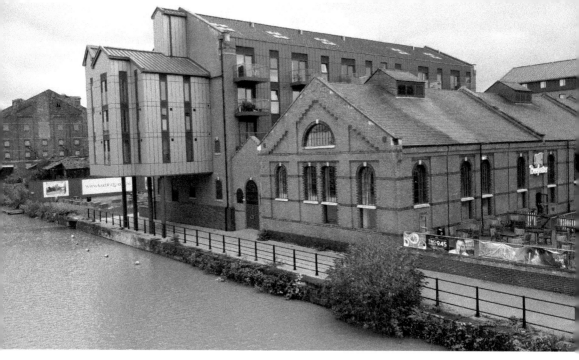

The new Provender building at Bakers Quay and the adjoining Engine House with the Malthouse Extension in the background.

homes alongside the canal. After being approved by the City Council in 2004, construction of the first phase started in 2007 with the outlet centre being opened in May 2009 by television star Gok Wan. The overall scheme was envisaged to be a ten-year project, but despite elements being delayed by aftermath of the financial crash of 2008, the development has largely been completed, other than some small elements outside the ownership of Gloucester Quays – principally the later phases at Bakers Quay.

In 2004, Gloucester established its own Urban Regeneration Company to oversee the rejuvenation of the city. It brought together the City and County Councils, the since-abolished Regional Development Agency and English Partnerships (the government's regeneration agency) together with board members from the public, private and voluntary sectors. Its full title was the Gloucester Heritage Urban Regeneration Company, or GHURC for short. It was the only urban regeneration company with the word 'heritage' in its title, reflecting the importance of Gloucester's historic fabric.

GHURC identified the 'Magnificent Seven' priority projects of Gloucester Docks, Gloucester Quays, Greyfriars, the Railway Triangle, Blackfriars, Kings Quarter and the Canal Corridor. It achieved some success with all of them, although its influence and funding was limited and it relied upon the financial strength and legal powers of its partners.

The regeneration of Gloucester Docks really gathered momentum after it was acquired by the South West Regional Development Agency (SWRDA) in the early 2000s. This enabled SWRDA to invest in the public realm, with high-quality

Forest of Dean stone paving replacing a sea of tarmac car parking. The Victorian warehouses were converted to characterful apartments, achieving prices not seen elsewhere in Gloucester. The first new build for a generation took place at the Barge Arm, with apartments alongside commercial units, such as cafes and restaurants, on the ground floor.

Ownership of the docks passed to the City Council when SWRDA was abolished in 2011. The council itself moved out of its docks offices in 2019, although it retained the Council Chamber in North Warehouse. Its former offices were initially earmarked for a hotel. The Food Dock, made up of a number of local, independent food and drink businesses, was due to open at the northern end of the docks in 2023.

The plans for a new further education campus for Gloucestershire College (formerly GlosCAT) at Llanthony Road as part of the Gloucester Quays development enabled English Partnerships to acquire their Brunswick Road campus in the city centre. English Partnerships (later the Homes and Communities

Above left and above right: Pedestrian linkages between Gloucester Quays, through the Docks, to the city centre.

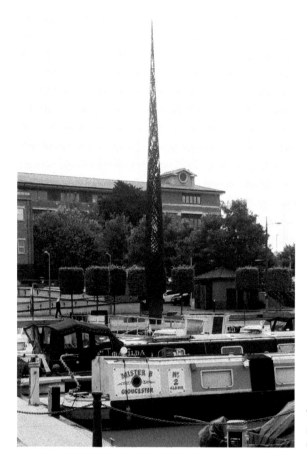

The Candle, a piece of public art at Gloucester Docks, towers over the Victoria Basin.

Agency) teamed up with Linden Homes to develop over 300 homes, bringing more people to live in the city centre.

The Railway Triangle had been derelict for many years and had a legacy of contamination. Creating a vehicle access from the main road at Metz Way was an added challenge. Over the years a number of different proposals had come and gone, including a leisure-based scheme with a cinema. GHURC initially proposed a Community Stadium, to be shared by Gloucester Rugby and Gloucester City Football Club, but the idea foundered when Gloucester Rugby decided to stay at their spiritual home at Kingsholm. The private sector found its own solution with a Morrisons supermarket providing the first phase and a number of other commercial uses, known as Triangle Park, making up the rest of the site.

Regeneration did eventually come to Blackfriars with the building of the Global Language Immersion Centre on Commercial Road, adjacent to Blackfriars Priory, although its use only lasted a short time as the language diploma it was designed to teach was abolished. It then became occupied by the County Council's Adult Education team. Blackfriars Priory itself, which was previously only open to the public from time to time, was taken on by the City Council and run as a venue for weddings and events.

A piece of railway public art near the Morrisons supermarket at the regenerated Railway Triangle.

Regeneration on any scale at Blackfriars didn't take place until after GHURC had been wound up and responsibility transferred back to the City Council. SWRDA had been buying up land in the area and on its demise this passed to the City Council. With the help of some grant funding from the government, the council did a deal with developer CityHeart to build student accommodation on land at the Barbican, housing students from the University of Gloucestershire's new Business School at its Oxstalls Campus and Hartpury College/University. The first phase of 295 beds opened in September 2018 and a second phase of another 200 was planned to complete in time for September 2022.

Despite winning awards in the 1970s, Kings Square's design didn't stand the test of time. By the late 1980s it was starting to look dated and run-down. A number of attempts were made to regenerate the Square and the wider area, including the 1960s bus station which also presented a poor image of the city. Some limited work took place in the 2000s to remove the defunct fountain area, fill in the 'bearpit' toilets and resurface the central area. The infamous derelict 'Golden Egg' building was acquired by the City Council in 2014 and demolished.

A new, modern bus station opposite the Land Registry building was developed by the City Council and opened in October 2018, with the help of a £6.4 million government grant. It was rebranded the 'Gloucester Transport Hub' because of its proximity to the railway station and taxi rank.

The wider plans for a retail-led redevelopment of Kings Quarter were abandoned in 2016 in the face of changing shopping habits, with online shopping rising inexorably. Some well-known national retailers went out of business while others trimmed back their network of stores. The revised Kings Quarter plan was

Left and below: The University of Gloucestershire's Oxstalls Campus, which opened in 2002, and the Business School, which was completed in 2018.

made up of a replacement multi-storey car park, hotel, offices and residential premises. When the City Council teamed up with developers Reef Group, who had acquired the Kings Walk shopping centre, there was a focus on the growing cyber sector to occupy the office space.

The City Council decided to refurbish Kings Square itself rather than rely on a developer. It approved a £5 million budget. Initial work started in autumn 2019 but was interrupted by the Covid-19 pandemic. The main contractor was local

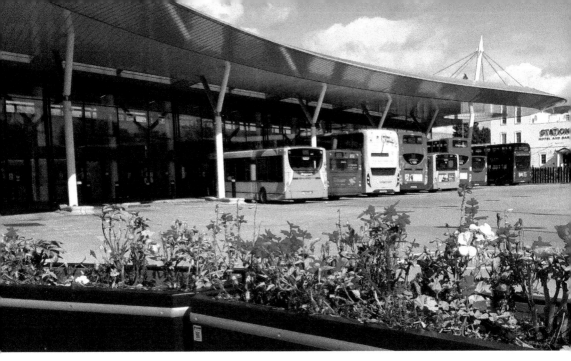

Above: Gloucester's new £8 million bus station or 'Transport Hub'.

Below: A collection of vintage buses line up for the official opening of the new Gloucester Transport Hub. (Colin Organ)

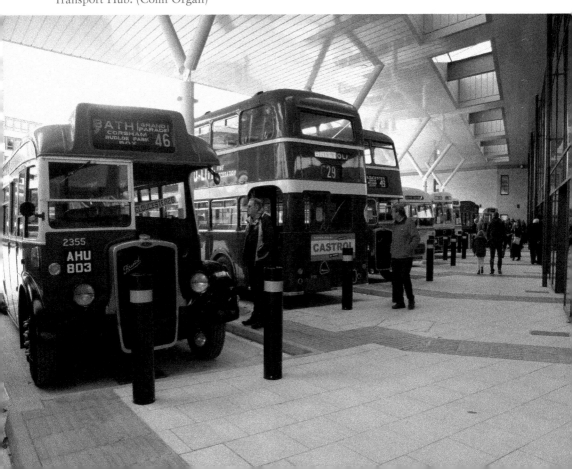

Above and below: Kings Square was redeveloped as part of the city's regeneration programme and was completed in 2022. These photos show the 'before' and 'after'. ('Before' photo: Colin Organ)

Regeneration taking place in the city centre at Kings Quarter/ The Forum.

firm E. G. Carter. The Square was officially opened in April 2022 – almost fifty years since the new square was unveiled the last time.

At the time of writing, the later phases of Kings Quarter were underway after the City Council boldly agreed to fund the £107 million cost of the scheme. When the Debenhams department store chain went into administration in 2021 their enormous building fronting Kings Square was bought by the University of Gloucestershire for a new city campus, teaching health and social care.

In October 2021, the City Council's bid for £20 million to the government's Levelling Up Fund was approved. In broad terms, £10 million was for the new university campus, £4 million for The Forge (an innovation centre as part of Kings Quarter) and £6 million for the former Fleece Hotel complex. The Fleece, which had been an inn since 1497, closed in 2002 and was acquired by SWRDA. Like the agency's other assets, it transferred to the City Council on its demise in 2011. The council undertook emergency works to protect the historic structure, including the twelfth-century undercroft known as the 'Monk's Retreat', but the council had struggled to find a developer partner to take it on – at least not without a big injection of cash. Hopefully the £6 million from the government will be enough to see it brought back into use after a generation of being closed.

Although the city's notable historic buildings are covered elsewhere in this book, the important heritage projects which formed part of Gloucester's regeneration programme should not go unmentioned here. Project Pilgrim at Gloucester Cathedral, the restoration of Llanthony Secunda Priory and the works to repurpose St Mary de Crypt and the Old Crypt Schoolroom represented a major investment of around £10 million by the Heritage Lottery Fund, with other funding provided by a range of partners.

Over £1 billion of private and public money has been invested in Gloucester's regeneration over the last twenty years, but at the time of writing there is still plenty to do before the job can be considered complete.

3

Gloucester at Work

Gloucester has long been a city of innovation and of manufacturing. Perhaps the city's most famous innovators are Hubert Cecil Booth, who invented the vacuum cleaner, and Sir Charles Wheatstone, who invented the 'Wheatstone Bridge', which is used to measure electrical resistance.

In the Middle Ages, the main export was wool, which came from the Cotswolds and was processed in Gloucester. Other exports included leather and iron. Gloucester also had a large fishing industry at that time. In the eighteenth century, the city's biggest industry was pin-making. It was said that it employed 1,200 men, women and children. Some of the city's most prominent buildings have been used for pin-making, including the Folk Museum in Westgate Street and the Irish Club in Horton Road. The unusual bollards in the city centre Gate Streets are said to represent Gloucester's pin-making history.

The Gloucester to Sharpness Canal.

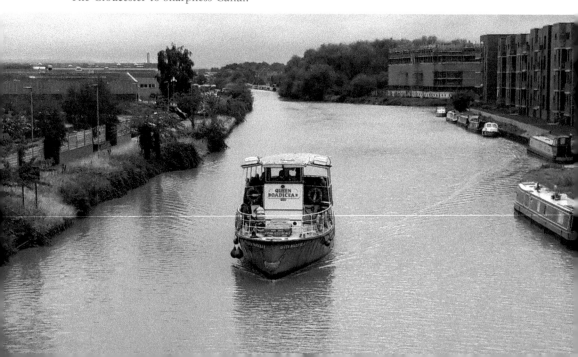

In the nineteenth century, Gloucester Docks was a bustling, working port, with the warehouses – which are now used as upmarket apartments, bars and restaurants – storing flour and grain for transport on the canal.

For many years, Gloucester was known as a centre for engineering, with a number of large employers like Fielding and Platt, the Gloucester Wagon Works Company and the Gloster Aircraft Company. Many of these factories were located close to what we now consider the city centre and often close to the docks and canal for reasons of transporting goods. As the focus shifted to road transport, the motorway network grew and the city expanded, many of these employers moved to business parks on the fringes of the city, like Gloucester Business Park and Waterwells.

Over the years, Gloucester's employment has changed. The city has long had strong connections with banking. The legendary 'Gloucester miser' Jemmy Wood, who is said to have inspired Charles Dickens' character of Ebenezer Scrooge in *A Christmas Carol*, ran the Gloucester Old Bank in Westgate Street (where McDonalds is now). The Bank of England opened its first branch outside London in Northgate Street in 1826 and the Registrar's Department of the Bank was based in Southgate House, opposite the docks, from 1991 to 2004. In the late twentieth century, the city's banking, insurance and finance sector grew with companies like the Cheltenham & Gloucester Building Society, Ecclesiastical Insurance, Laurentian Life and Northern Star. It continues to this day with companies including the Benefact Group and Ageas at Gloucester Business Park and Pro-Global at Southgate House.

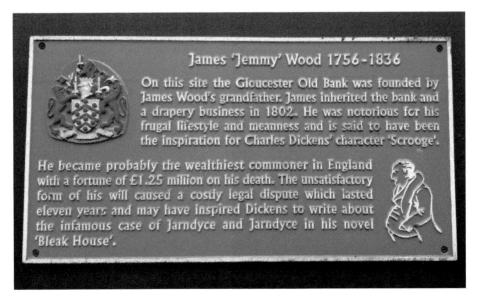

A plaque on what is now McDonald's commemorates the 'Gloucester Miser', Jemmy Wood.

As the administrative headquarters of the county, Gloucester is a hub for public services, with the City and County Councils, the NHS and the Land Registry being large employers in the city.

Some people say that 'nothing is made in Gloucester anymore'. That isn't correct. It may be true that there are fewer large manufacturing employers, but more is made in Gloucester than people probably appreciate. This chapter takes a look at some of Gloucester's most notable businesses past and present.

Morelands Matches

Samuel Moreland, from Stroud, moved to Gloucester in 1867 and opened the Moreland Trade Factory (which still stands today, on Bristol Road) to manufacture Lucifer and Vesta matches. By 1907 they were employing 640 people, but with the introduction of automated machinery this had reduced to 350 by 1919. The girls who were employed in the factory were known as 'Sammy's Angels' in his honour.

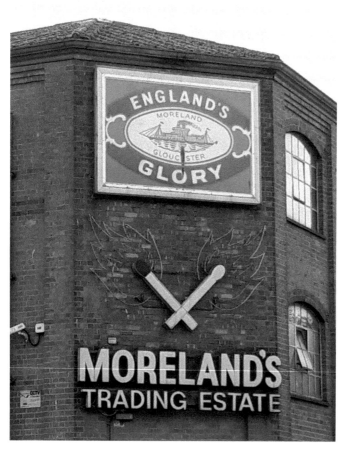

The Moreland's Trading Estate on Bristol Road.

The company became a subsidiary of Bryant and May in 1913, although full ownership by Bryant and May only came in 1938. The England's Glory brand uses a celebrated image of a Victorian battleship, HMS *Devastation*.

The family management of the business ended in 1972 and, with Bryant and May having been acquired by Swedish Match, the factory was closed in 1976. The former factory was converted into a small trading estate. There is an 'England's Glory' illuminated sign on the main building which has been unlit for some years. There is a hope that repairs could be carried out to see it lit again at some point in the near future.

The electoral ward of Moreland, Gloucester, is named after the factory. Actress Emma Watson, who played Hermione Watson in the *Harry Potter* film series, was spotted in 2014 holding an 'England's Glory' design handbag by top designer Anya Hindmarch. The public house 'England's Glory' in London Road, Gloucester, is named after the matches.

The Gloster Aircraft Company

The Gloster Aircraft Company was a British aircraft manufacturer from 1917 to 1963. Founded as the Gloucestershire Aircraft Company Limited during the First World War, with the aircraft construction activities of H. H. Martyn & Co. Ltd of Cheltenham, it produced fighters during the war. It was renamed later as foreigners found 'Gloucestershire' difficult to pronounce. It later became part of the Hawker Siddeley group and the Gloster name disappeared in 1963.

GAC designed and built several fighters that equipped the British Royal Air Force during the interwar years including the Gladiator, the RAF's last biplane fighter. The company built most of the wartime production of Hawker Hurricanes and Hawker Typhoons for their parent company Hawker Siddeley while its design office was working on the first British jet aircraft, the E.28/39 experimental aircraft. This was followed by the Meteor, the RAF's first jet-powered fighter and the only Allied jet fighter to be put into service during the Second World War.

The site at Brockworth ceased to be operational in 1962 and was sold in 1964. For many years it was known as the Gloucester Trading Estate. Property company Arlington began developing the site in the early 1990s for office, industrial, residential and retail uses. Occupiers of what is now known as Gloucester Business Park include Laithwaites Wines, Wincanton logistics, TBS Engineering, Royal Mail, Lockheed Martin, Dowty Propellers, EDF Energy and Benefact Group (formerly Ecclesiastical Insurance), as well as a Tesco Superstore, Premier Inn Hotel and a David Lloyd Racket & Health Club.

Much of the history of the Gloster Aircraft Company, and other similar local firms like Dowty Rotol and Smiths Industries, is on display at the volunteer-run Jet Age Museum at Staverton.

Gloucester Business Park, on the site of the former Gloster Aircraft Company, at Brockworth.

Gloucester Railway Carriage and Wagon Company

The Gloucester Railway Carriage and Wagon Company, or The Wagon Works as it was known, was a railway rolling stock manufacturer based in Gloucester from 1860 until 1986, located at what we now know as the Peel Centre retail park. The company supplied trains for railways around the world, including the London Underground, Toronto Subway and Australia. During the Boer War the company manufactured horse-drawn ambulances and during the First World War, produced stretchers, ambulances, and shells as well as wagons.

In 1936, the firm won the contract to build a 68-foot-long air-conditioned carriage for the Maharajah of Indore to be designed by a German architect and to include a kitchen, servants' quarters and a nursery. By 1937, the firm had a 28-acre site and employed 2,400 people.

During the Second World War the company produced tank-carrying wagons, shells, and other parts and equipment and by 1941 the company began producing Churchill tanks, making 764 units by 1945. After much work was lost to foreign competitors, Powell Duffryn Rail acquired the remains of the company in 1986, but its operations ceased in 1993–94.

Wall's Ice Cream

Wall's Ice Cream was originally founded in London by a butcher's firm to provide a summer product for the time of year when sales of its sausages, pies and meat

fell. The company is known for their iconic 'Stop Me and Buy One' tricycles. In 1939, there were 8,500 of them on the road.

By 1922, the business had been jointly bought by Lever Brothers and Margarine Unie, and ice cream production commenced in 1922 at a factory in Acton, London. In 1959, it expanded by starting work on a purpose-built ice cream factory in Gloucester. The site was officially opened in April 1962. The site was built to supply 25 million people in the west and north of England, and Wales. In the 1960s, the site had over 1,000 employees and was the world's largest ice cream factory. At its peak, the site could produce 90,000 gallons of ice cream a day and 2 million lollies a day. In March 1995, the site was visited by Queen Elizabeth II and the Duke of Edinburgh, and the Queen planted a commemorative tree.

These days, the company occupies far less land than it did at its height, with the Barnwood Point business centre and Centre Severn leisure park built adjacent to the remaining operation. The roundabout at the intersection of Eastern Avenue and Barnwood Road, which famously is home to a number of rabbits, is still known as 'Wall's Roundabout' from when it was located at the entrance to the site.

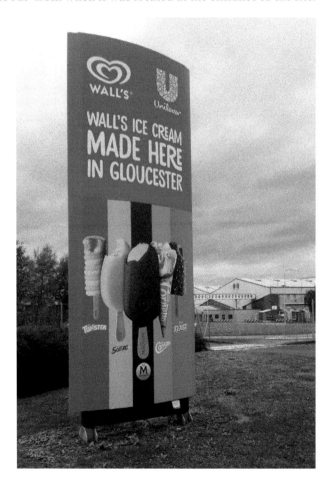

The Wall's ice cream factory at Barnwood.

Cheltenham & Gloucester Building Society

The C&G can trace its roots back to the Cheltenham and Gloucestershire Permanent Mutual Benefit Building and Investment Association founded in 1850. Its first Gloucester branch opened in 1896. During the 1980s, C&G acquired several smaller building societies, as consolidation of the sector intensified. Its headquarters were at Cheltenham House in central Cheltenham until their move to Barnwood in 1989.

C&G converted to a bank in 1995, as result of a takeover by Lloyds TSB. At the time it was the sixth largest building society in the UK. This involved the demutualisation of the society, and generated a windfall payment to its members. Gloucester's MP at the time, Douglas French, introduced a bill in Parliament to ensure widows who previously held joint accounts, who would otherwise have been excluded, got their windfall payment.

C&G were generous supporters of local sport, sponsoring both Gloucester Rugby and Cheltenham Cricket Festival as well as the 'Welcome' signs heading into both the town and the city.

C&G's mortgage business was rebranded to Lloyds-TSB in 2009 and its branches rebranded to TSB in 2013. The former HQ at Barnwood has been retained by the Lloyds Banking Group, with the second building (formerly known

The former Cheltenham & Gloucester Building Society HQ at Barnwood, now used by the Lloyds Banking Group.

as Barnwood 2) used by TSB following their split from Lloyds. The roundabout next to the former HQ is still known as the 'C&G roundabout'.

Ecclesiastical Insurance

Ecclesiastical Insurance rebranded as Benefact Group in 2022. Ecclesiastical were founded in 1887 by the Church of England to provide insurance cover for its buildings. Customers include Gloucester Cathedral and St Paul's Cathedral. It now covers a wide range of insurance business.

The group is owned by Benefact Trust (previously known as Allchurches Trust), a registered charity whose objectives are to promote the Christian religion and to provide funds for other charitable purposes.

The company moved offices from Brunswick Road in the city centre to Gloucester Business Park in 2020, having abandoned plans for a new HQ at Gloucester Docks in 2013. In 2022, the company set an ambition to become the UK's biggest corporate donor after achieving its goal of giving more than £100million to good causes in the previous five years.

Fielding & Platt

Fielding & Platt was a firm of hydraulic engineers founded in 1866 who were an important part of the manufacturing sector in Gloucester until the 2000s. The company was started by two Lancashire men, Samuel Fielding and James Platt, and was renowned for the quality of its work. It was involved in a remarkable range of projects.

In 1870, they produced the steam boat SS *Sabrina* which was used on the canal between Gloucester and Sharpness. The *Sabrina* is still in use on the Thames and took part in the Diamond Jubilee River Pageant in June 2012.

In 1880, they built a bridge across the Severn at Gloucester Docks, adjacent to the North Warehouse, which was not replaced until 1962. The firm's portable hydraulic riveter was used in the construction of the Forth Bridge in 1890. The firm worked on the construction of Blackpool Tower and in 1902 Fielding & Platt manufactured the first vacuum cleaner, designed by Hubert Cecil Booth, also of Gloucester.

During the Second World War, the factory manufactured munitions and parts for Hurricanes and Spitfires. Many more women worked for the company as many of the men had been called up for military service. By 1961, the company had 620 employees. The Fielding & Platt name was dropped in 1999 following a takeover. Manufacturing ceased in Gloucester in 2000 and the remaining office closed in 2003. Fielding & Platt's Atlas Works were on what we now know as Gloucester Quays.

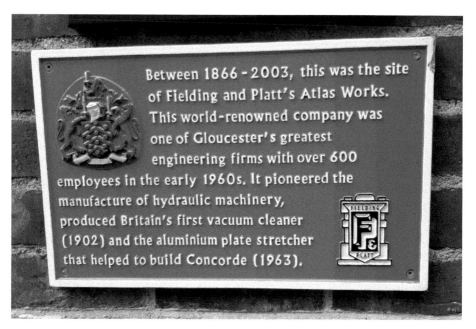

Between 1866 - 2003, this was the site of Fielding and Platt's Atlas Works. This world-renowned company was one of Gloucester's greatest engineering firms with over 600 employees in the early 1960s. It pioneered the manufacture of hydraulic machinery, produced Britain's first vacuum cleaner (1902) and the aluminium plate stretcher that helped to build Concorde (1963).

Fielding and Platt's Atlas Works were at what we now know as Gloucester Quays.

G. R. Lane Health Products

These days known as LanesHealth, G. R. Lane Health Products was founded in 1930 by Gilbert Lane. Initially working from his home in the Gloucestershire town of Newent, the business grew rapidly and by 1940 was operating from premises in Gloucester. In 1974 the company moved to brand-new, purpose-built premises in Sisson Road, Elmbridge, from where they still operate today.

The company is most famous for making the Olbas Oil decongestant product and Kalms herbal remedies. They also own the company who make the Jakemans menthol sweets, although these aren't made in Gloucester.

Today the company remains in the hands of the Lane family, with the founder's grandchildren and great-grandchildren all playing active roles in the business.

Permali

Founded in 1937, some of Permali's most famous projects include developing propeller blades for the Spitfire and Hurricane aircraft during the Second World War, developing Permaglass Cargo Liners installed on the Concorde and the production and supply of composite laminate machined planks to Formula One motorsport teams. The company still designs and manufactures composite and thermoplastic material solutions for the defence, aerospace, Formula One, medical and rail sectors from part of its historic site on Bristol Road, with the rest given over to a trading estate.

Other Businesses

Other success stories include Prima Dental, who are now based on the Waterwells Business Park at Quedgeley, employing more than 200 people locally. The company manufactures dental burs (tiny drill pieces). They moved to Gloucester in 1974, initially being based at the Madleaze Trading Estate on Bristol Road. More than 90 per cent of their production is exported to ninety-three countries around the world.

Severn Glocon were founded in 1961 and were located for many years in Southgate Street on what is now part of the Gloucester Quays site. Now based at Olympus Park in Quedgeley, they manufacture of control valves for the oil and gas industries and export their products all over the world.

One piece of manufacturing which still takes place in the city centre is Emma Willis's shirt-making operation, which is run from the historic Bearland House in Longsmith Street. The company hand-makes bespoke shirts for its shop in London's famous Jermyn Street and counts King Charles III, Benedict Cumberbatch, Colin Firth and 007 Daniel Craig amongst its clients.

These days, Gloucester is working to grow its high-tech businesses, with the development of a cyber and digital quarter at The Forum, adjacent to the bus and railway stations. It must be hoping it can repeat the success of Fasthosts Internet, based in Southgate Street.

Fasthosts was started by Andrew Michael, then at the age of seventeen, as part of an A-level school project. It became a limited company in 1999 and in 2002 was listed as the second fastest-growing technology company in the UK by *The Sunday Times*. In 2005, the company had a turnover of £20 million and made £5 million profit. The company also became known for hosting lavish staff Christmas parties. Its event in 2005 cost £600,000 and featured appearances from Jonathan Ross, The Darkness and Boney M.

In 2006 Fasthosts was sold to German firm United Internet for £61.5 million, netting Andrew Michael £46 million for his 75 per cent stake. He remained as Chief Executive until 2009, when he left to found another tech company, Livedrive.

Gloucester at Play

Gloucester is a city that likes to work hard and play hard. This chapter covers some of the key features of the city for leisure and enjoyment.

Gloucester Rugby Club

Gloucester Football and Athletic Club was founded in 1873 following a meeting at The Spreadeagle Hotel in Northgate Street. It was an exclusive club at the time, made up of solicitors, bankers and the like. Roads in a small development in the city suburb of Coney Hill are named after key figures in the Club's history – Hartley Close after solicitor Frank Hartley, one of the founders of the club, and Boughton Way, after Jimmy Boughton, who organised the purchase of the Kingsholm site. Although the iconic Kingsholm Stadium is synonymous with Gloucester Rugby Club, their first ground was at The Spa near Gloucester Park, where they shared it with a cricket club, leaving when it was felt the two sports were incompatible in terms of maintaining a playing surface.

It's also not widely known that Gloucester haven't always played in cherry and white. Club records show them playing in a variety of colours for the first twenty years of their existence before adopting the cherry and white strip. A legend exists that they borrowed a kit from local club Painswick and then adopted the colours. Club archivists haven't found proof of this – but are happy to accept it as a good story!

As with any sports club, their fortunes have waxed and waned over the years, but several sides are worthy of mention. The team from the 1882/83 season became known as The Invincibles, playing 14 matches, winning 11 and drawing 3. In 1972, the club won the John Player Cup. Captained by the legendary Mike Nicholls, they beat Moseley in the final. In the 1981/82 season, captained by Steve Mills, the club played 48, won 41, drew 4 and lost 3.

Mike Teague is widely regarded as the greatest rugby player ever to have come out of Kingsholm. He made his full England debut in 1985, going on to win

27 caps and being part of the Grand Slam-winning team of 1991. He toured twice with the British Lions – to Australia in 1989 when the Lions came back from 1-0 down to win the series 2-1 and to New Zealand in 1993. Teague was named 'man of the series' for the 1989 tour.

When the sport turned professional in 1995, the club needed a big investor in order to compete. In 1997, the Club was bought by Formula One motorsport tycoon Tom Walkinshaw, who lived just over the border in Oxfordshire. He oversaw a revolution at Kingsholm, with players recruited from around the world, a new management team to exploit commercial opportunities and the phased redevelopment of the stadium – although to this day the iconic Shed has remained untouched. On his death in 2010, the reins were gradually handed over to Walkinshaw's son Ryan, but the family sold their shareholding to current Chairman Martin St Quinton in 2016.

At the end of the 2001-2 season, Gloucester won the 'Premiership Cup' – a play-off between the top eight teams in the league. The following season, they were the standout team in the league, topping the table by 15 points. Gloucester won the Powergen Cup, beating Northampton in the final at Twickenham but missed out on winning the Premiership as it had moved to a play-off system and they lost in the final to Wasps.

Later that year (2003), England won the Rugby World Cup. Three Gloucester players (Phil Vickery, Trevor Woodman and Andy Gomarsall) were part of the

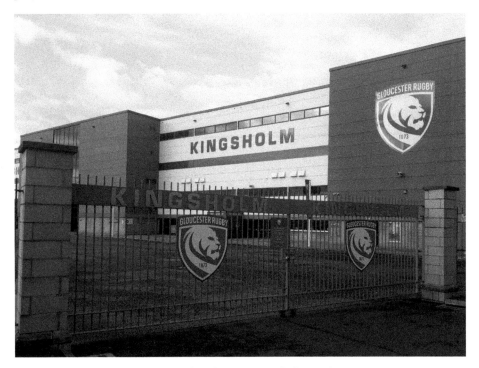

The main stand at Gloucester Rugby's famous Kingsholm Stadium.

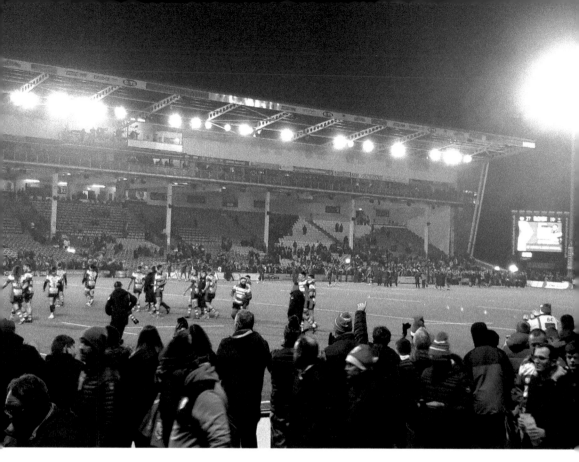

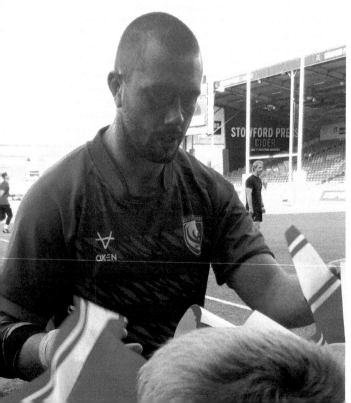

Above: A match at Kingsholm played under the lights.

Left: Gloucester Rugby captain Lewis Ludlow signs autographs for fans at an open training session at Kingsholm.

winning squad, with Vickery and Woodman starting in the final against Australia. The City Council awarded the Freedom of City to the three players. Vickery still lives locally, running a restaurant in Cheltenham as well as his Raging Bull clothing business, and is a Deputy Lieutenant for Gloucestershire. Woodman is still involved with the club as Forwards Coach. Gomarsall moved away and now describes himself as an entrepreneur and environmentalist.

Winning the Premiership continues to elude the club, but it picked up the second-string European Challenge Cup trophy in 2006 and 2015, beating London Irish and Edinburgh in the finals respectively. Gloucester also won the Anglo-Welsh LV Cup in 2011, beating Newcastle in the final 34-7.

Kingsholm Stadium hosted four matches in the 2015 Rugby World Cup – Tonga v Georgia, Scotland v Japan, Argentina v Georgia and the final pool match of the tournament, USA v Japan. It wasn't the first time Kingsholm had seen Rugby World Cup action. In 1991 they hosted New Zealand v USA, but that was in the early days of the tournament without much of the infrastructure that goes with it today, such as a Fanzone (which in 2015 was located at the docks) and dressing the city.

Gloucester Rugby is a big economic force in the local economy, bringing millions of pounds of spend to the city and putting Gloucester on the map, as well as being a great unifying force. Gloucester's world-famous stand 'The Shed' contains people of all backgrounds – but once inside it, everyone is equal!

Gloucester City Football Club

Gloucester City Football Club may not have the profile of its rugby team or have enjoyed the same level of success, but it is still an important part of city life. Gloucester City Football Club can trace its roots back to 1883 and has played at a number of different locations in the city – most recently in Longlevens and Horton Road, near the hospital, before moving to its current site in Sudmeadow Road, Hempsted. The former stadium at Horton Road was developed for housing, with the roads named after some of City's most illustrious players.

The stadium at Hempsted, known as Meadow Park, was engulfed in the floods of summer 2007, with the floodwaters almost reaching the crossbar on the goalposts. The damage, and the need to take action to avoid a recurrence, meant City were effectively homeless for well over a decade. A hardcore of devoted fans followed them around as they shared grounds with Forest Green Rovers, Cirencester Town, Cheltenham Town and then Evesham Town. The club returned to Meadow Park in September 2020 after the pitch had been raised by 4 metres and new stands had been built, including one named after the player who had appeared most times for the club, Tom Webb. Cruelly, soon after their return, they were forced to play a number of games behind closed doors because of the Covid-19 pandemic. That season was abandoned, with the club sitting at the top of the table.

Left and below: Gloucester City Football Club's stadium at Meadow Park in Hempsted was flooded in July 2007 and the club didn't return until September 2020. (Neil Phelps)

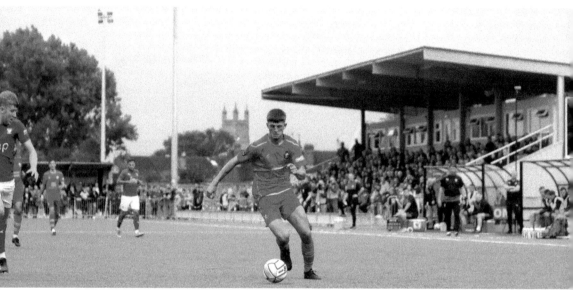

Leisure facilities

Gloucester is blessed with a range of other sporting facilities. Its main leisure centre, GL1, reopened in August 2002 after an extensive rebuild and contains a range of facilities, including a 25-metre competition pool with a moveable floor and a health and fitness suite. It has hosted a number of top-class synchronised swimming competitions. The dry ski slope on the side of Robinswood Hill at Matson, which opened in 1974, was where Olympic ski jumper Eddie 'The Eagle' Edwards practised. Edwards has been a regular at the slope since 1976 and now has a café, 'Eddie's Ski Shack', named in his honour. The ski slope is the longest in England and Wales after being extended to 255 metres.

The Gloucester Boathouse at Hempsted, alongside the canal, is a rowing facility for the whole county, and is used by Gloucester Rowing Club, Cheltenham College

Above: GL1, Gloucester's main leisure centre.

Right: The artificial ski slope on the side of Robinswood Hill at Matson. (Visit Gloucester)

and Hartpury University, amongst others. It stages a number of regattas each year. The athletics track at Blackbridge in Podsmead, now renamed the Jubilee Athletics Track, was upgraded in 2012 following a long campaign by the local athletics community. The cost was met from a number of sources including Severn Trent as part of their compensation for the loss of water supply after the 2007 floods and developer contributions following the loss of sporting facilities at the former British Energy site at Barnwood. The new facility was officially opened by the Princess Royal in February 2013. There are plans for a wider sporting facility at Blackbridge which have been in the planning stage for a number of years and, at the time of writing, are the subject of a planning application.

Gloucester has an active amateur cricket scene, but sadly the professional game no longer comes to the city, with the Gloucestershire ground firmly rooted in Bristol, with just the annual outing to Cheltenham in August. For many years,

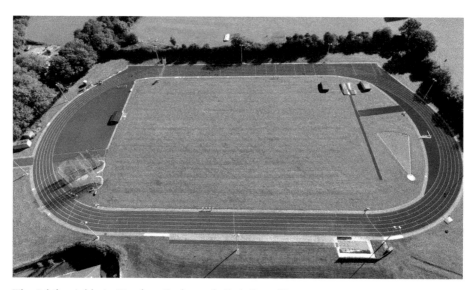

The Jubilee Athletics Track at Podsmead. (Bob Purcell)

there was a Gloucester Cricket Festival – first of all at the Winget Ground in Tuffley Avenue (until someone sprayed weedkiller on the wicket) and then at the King's School's Archdeacon Meadow playing field – until the club decided that upping sticks for a few days simply wasn't viable. Perhaps the most famous cricket ground in the city is the Spa Ground at Gloucester Park, where W. G. Grace scored 183 not out versus Yorkshire on 30 June 1887. Gloucester MP Richard Graham, who lives nearby, is a keen and regular cricketer as part of the Gloucester Cricket Club team. Perhaps the most famous cricketer to emerge from the city is fast bowler David Lawrence, who grew up in Tredworth and went on to play for Gloucestershire and England, and became President of Gloucestershire County Cricket Club in April 2022.

For many years, the Cambridge Theatre at Gloucester Leisure Centre was the focus for music concerts in the city. Performers there included Bucks Fizz, Culture Club, Duran Duran and Shakin' Stevens. Prior to that, The Regal in Kings Square (now a Wetherspoons pub) had seen a number of big names on the bill, including The Beatles who played there in 1963 as a support act to Chris Montez. Since the Leisure Centre was rebuilt in the early 2000s, the number of concerts has been limited, with only Joan Armatrading and Sir James Galway having made appearances.

Gloucester Guildhall has been the focus for live music in recent times, with Lily Allen, Charlotte Church and Robert Plant amongst those who have appeared on stage. The Guildhall's capacity is limited to 400, which acts as a constraint on the performances they can attract. Since 2011, Gloucester Rugby's Kingsholm Stadium has hosted summer concerts. The first concert was performed by boy band 'The Wanted', who included Gloucester's own Nathan Sykes. Other artists have included Sir Tom Jones (twice), Sir Elton John, Lionel Richie, Jess Glynne,

Madness and Ronan Keating. No concerts have been staged in recent years, with the Covid-19 pandemic and a new artificial playing surface the most likely explanation.

The city is less well-served with theatres these days, with the Kings Theatre in Kingsbarton Street, which has a capacity of just over 100, being the only dedicated theatre left in the city. Over the years, a number of theatres in the city have disappeared. Charles Dickens is said to have performed at the Theatre Royal in Westgate Street. The above-mentioned Regal in Kings Square and Cambridge Theatre at the Leisure Centre have both gone. The New Olympus, also known as The Picturedrome, in Barton Street has also sadly been lost as a functioning theatre – for the time being at least. The Gloucester Operatic and Dramatic Society (GODS) bought the theatre in 1986. It famously underwent a superficial makeover as part of Anneka Rice's television show *Challenge Anneka* in the 1991. I appeared at the theatre in pantomime in 2005, playing Alderman Fitzwarren in *Dick Whittington*, which I hugely enjoyed. The GODS sold the theatre in 2007 when the maintenance of what had become a listed building became too much of a burden. Subsequent attempts to refurbish and reopen the theatre have not come to fruition.

As a historic city, Gloucester unsurprisingly has a number of museums. The main museum run by the City Council is the Museum of Gloucester in Brunswick Road. The ground floor of the museum underwent a refurbishment in 2011, but the first-floor display is largely the same as it was when I was a child. The two most important items in the Museum of Gloucester, in my view, are the Birdlip Mirror (a Celtic art hand-held bronze mirror) and the Gloucester Tables set (the oldest complete backgammon set in existence). There is also the gravestone of Mercian Warrior Queen Aethelflaed. An exposed section of the city's Roman wall can be seen inside the museum. The city's museum collection totals over 1 million items, many of these human bones which have been discovered in archaeological excavations. Further recent discoveries include an 1,800-year-old 'Venus' figurine on the site of the new Forum development, which made national and international news.

The Folk Museum in Westgate Street was run for many years by the City Council but in 2021 was transferred to the Gloucester Civic Trust who now run it as a heritage centre rather than a museum and have renamed it as 'The Folk of Gloucester'.

The National Waterways Museum opened in Gloucester Docks in 1986 and was officially opened by the then Prince Charles in 1988. It underwent a three-year, £1.4 million refurbishment, finishing in May 2018, with almost £1 million of it financed by the Heritage Lottery Fund.

The Soldiers of Gloucestershire Museum spent thirty years in Westgate Street, in part of what is now The Folk of Gloucester, before moving to its premises in Gloucester Docks in 1980. It underwent a refurbishment with the help of funding from the Heritage Lottery Fund, reopening in 2014. The City of Paju in South Korea generously donated £94,000 to the museum in 2013 to create a Korean

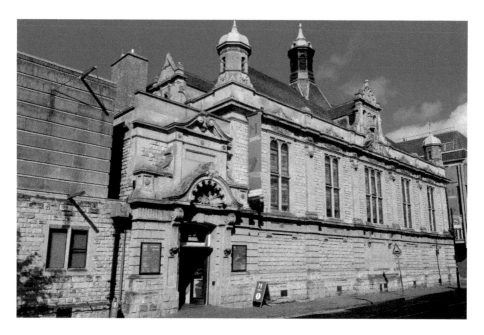

Above: The Museum of Gloucester in Brunswick Road.

Left: The Birdlip Mirror, probably the most important exhibit in the Museum of Gloucester.

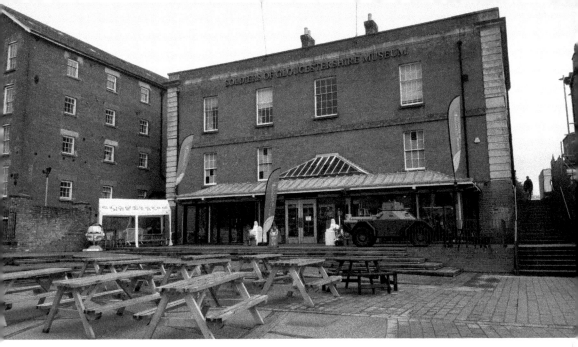

The Soldiers of Gloucestershire Museum at Gloucester Docks.

War gallery. The museum holds four Victoria Crosses awarded to soldiers from the Gloucestershire Regiment.

Gloucester's nightlife has changed over the years. At one point there were a number of nightclubs – Cinderellas next to the Leisure Centre in Bruton Way, Crackers by the bus station, KCs in Quay Street, Jumpin' Jaks in Brunswick Road and Innteraction (later The Registry) next to the Pint Pot in Bruton Way. The relaxation of licensing rules in 2005 meant people no longer had to go to a nightclub to have a late-night drink. Café Rene in the Greyfriars area of the city centre was granted a twenty-four-hour licence and became the focus for those who wanted to carry on socialising until the small hours but didn't want to go to a nightclub. The police also promoted a policy of concentrating late-night activity in the lower Eastgate Street 'strip', which they felt would make it easier to contain. The City Council even introduced a late-night road closure to prevent conflict between revellers and vehicles and brought in taxi marshals to get partygoers home safely.

These days the remaining nightclub business is split between Atik (a successor to Cinderellas), still next to the Leisure Centre but behind the façade of the Victorian baths following its relocation when the Centre was rebuilt, Jax in Brunswick Road and Butlers, which is run by City Councillor and long-time Chair of the Gloucester Licensed Victuallers Justin Hudson – who started as a glass collector in the bar and ended up buying it with a loan from his mum – and Bar Fever in Eastgate Street.

The rest of the city centre's night-time economy is made up of historic inns like the New Inn, The Fountain, The Old Bell and the Robert Raikes' House. The city centre has a number of restaurants, which are mostly independently owned, with many of

them Indian, Chinese and Thai. The family chain restaurants are centred around the leisure quarter at Gloucester Quays. Initially only Pizza Express and Nandos opened at the Quays, but the relocation of the cinema from the Peel Centre to Gloucester Quays in 2014 saw a number of restaurants open on the back of it and the area has flourished ever since. The Wetherspoons pub 'The Lord High Constable of England' and Gloucester Brewery's 'Tank' bar in Gloucester Docks add to the offer, along with popular independent restaurants and bars and the Gloucester Food Dock, made up of independent food and drink businesses, which is due to open in 2023.

Film Location

Gloucester has long been a location for filming. As a child I remember the BBC series *The Oneiden Line* being filmed in the then largely derelict Gloucester Docks. In more recent years, there has been a conscious and concerted effort to promote the city as a film location due to the huge economic benefits it brings. The docks and the area around it is still an important part of that offer, as is the cathedral – which, as the city's two main attractions, is perhaps not surprising.

In recent years, the docks has been the setting for parts of the film *Alice Through the Looking Glass*, which starred Johnny Depp and Helena Bonham-Carter, although neither are believed to have filmed at this location. Co-star Mia Wasikowska, who played Alice, did film on-site. The restored Victorian warehouses were dressed to make them look run-down and industrial again – and anything which couldn't be done physically was done with the help of technology. The filming took over much of the docks for a week and brought in a huge entourage which included 300 crew, 150 extras, forty technical vehicles, eighteen horses, five tall ships, two techno cranes and two llamas!

The docks was the location for *The Colour of Magic*, a drama series for Sky starring David Jason, which filmed there in 2006, while the then derelict warehouses of Bakers Quay were the backdrop for *Amazing Grace*, a film about the abolition of slavery.

Gloucester Cathedral is most famous in filming terms for J. K. Rowling's *Harry Potter*. The cathedral's magical cloisters were used in the *Philosopher's Stone* (2001), the *Chamber of Secrets* (2002) and the *Half-Blood Prince* (2009). An electrical switch was covered up using a stone-painted timber frame which is still in place and is known as the 'Harry Potter box'. The cathedral and its precinct has been used for a number of other high-profile filmings including *Henry IV & V* (starring the late Geoffrey Palmer of 'Butterflies' fame and Tom Hiddleston), *Doctor Who* (with David Tennant for the Christmas episode in 2008 and Jodie Whittaker who filmed there in May 2019) and *The Spanish Princess*.

Other locations in the city have also been used, sometimes not particularly glamorous ones. Parts of the film, 'Outlaw' starring Sean Bean and Danny Dyer, were filmed in a white transit van in the car park of the Land Registry in Bruton Way.

Events

Gloucester's programme of large-scale events has been transformed in recent years and is constantly evolving. As a child I remember watching the Gloucester Carnival make its way along Parkend Road from The Lannett, with numerous extravagantly decorated floats. The city's two main department stores – Debenhams and the Co-op – would compete to be the best float. In those days, it was a serious battle between their two sets of professional window dressers. Sweets would be thrown from the vehicles in a way that health and safety rules wouldn't allow now.

The carnival declined over the years due to health and safety rules, the difficulty of getting large vehicles through the pedestrianised city centre streets and businesses and other organisations struggling to find the time and resources to decorate floats. Despite efforts to recast it as predominantly a walking procession, it never returned after the Covid-19 pandemic, bringing to an end over eighty years of carnival history.

However, many new events have been introduced. Gloucester's signature event is the Tall Ships Festival at Gloucester Docks. It first took place in October 2007 as a way of promoting the city as 'open for business' after that year's summer floods. It has taken place every two years since, other than a break during the pandemic. A number of Tall Ships make their way up the Gloucester Sharpness Canal into the main dock basin. Large crowds board the ships over the course of several days with other water-based activities such as flyboarding taking place. A mix of music, food and drink, stalls and nautical characters bring the surrounding land to life.

Since the opening of Gloucester Quays, several large-scale festivals have regularly taken place in the docks including the Food Festival with stalls and cooking demonstrations and Christmas Markets, which now have an added feature of an ice rink in Orchard Square, by the National Waterways Museum.

Over the years, the Christmas lights switch-on event in the city has taken many forms. For many years Father Christmas arrived by boat at the docks before heading into the city centre. There have been celebrity switch-ons with the likes of Keith Chegwin and Christopher Biggins. In more recent times, there has been a Lantern Procession starting at Blackfriars Priory and making its way through the city centre streets to Gloucester Cathedral. The lanterns, based on a different theme each year, are made by local schoolchildren with the help of an artist and carried by the children, ending up with a very informal short service at the cathedral.

The biggest and most popular event in the heart of the historic city centre is Gloucester Goes Retro. Founded by former Mayor Colin Organ, it brings hundreds of classic cars into the gate streets which are each given a different decade as a theme. Dancing and other performances take place in Kings Square. Pop group 'The Real Thing' performed there at the 2019 event. A regular feature

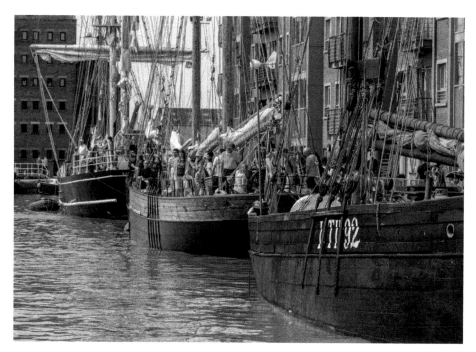

The Tall Ships Festival at Gloucester Docks. (SoGlos)

Flyboarding taking place at Gloucester's Tall Ships Festival.

of Gloucester Goes Retro for a number of years was the appearance of a number of '*Allo 'Allo!* characters including Helga (Kim Hartman), Yvette (Vikki Michelle), Herr Flick (Richard Gibson), Lieutenant Gruber (Guy Siner), and Officer Crabtree (Arthur Bostrum). The event made headlines around the world in 2018 by bringing the cast together for the first time in twenty-six years.

Above: The 'Gloucester Goes Retro' festival in the heart of the city centre.

Right: The late Colin Organ, founder of 'Gloucester Goes Retro', with stars from the '*Allo, 'Allo!* television sitcom. (The family of Colin Organ)

Two of the city's most enduring events are the Blues Festival and the Cajun and Zydeco Festival. The Blues Festival, which has been running for over twenty years, sees R&B acts playing in the city's pubs at the end of July. The Cajun and Zydeco Festival, which is Europe's longest-running such event, has been taking place at Gloucester Guildhall for nearly thirty years and brings repeat visitors from around the country – and around the world.

Open Spaces

Gloucester is only a short drive from both the rolling hills of the Cotswolds and the beauty of the Forest of Dean, but it has some pretty special open spaces of its own within the city. Several of them have been awarded Green Flag status – the international recognition for well-managed open spaces. Three of them – Robinswood Hill, Plock Court and Gloucester Park – were awarded Queen Elizabeth II playing field status by Fields in Trust to mark the Diamond Jubilee in 2012. To be awarded this, the City Council had to enter a legal commitment to preserve them as open spaces in perpetuity.

Robinswood Hill, just a couple of miles to the south-east side of the city centre, offers far-reaching views across the Severn Vale, Cotswolds and over to the Forest of Dean. The Domesday Book refers to Robinswood Hill as Mattesdon, but it gets its present name from the Robins, a local Matson family who had rights to graze sheep here during the Elizabethan period. Robinswood Hill Country Park extends to 100 hectares, all cared for by the City Council. The country park has wildflower meadows and a woodland which support a rich variety of wildlife. The wider country park has traditional orchards and ponds. The quarry is designated a Site of Special Scientific Interest (SSSI) due to the layers of rock that date back to the Jurassic period.

In recent years, the hill has been improved with the addition of a number of features including wood sculptures. During 2019–20, Gloucestershire Wildlife Trust's head office was redeveloped to include a new indoor café and visitor hub, which opened in September 2020. A beacon on top of the hill is lit on special occasions, such as jubilees.

Barnwood Park and Arboretum are situated off Church Lane, across the road from St Lawrence's Church. The current park and arboretum are the remainder of the Barnwood House Estate. The main house was demolished in 2001.

The original Barnwood House was built in the early 1800s and had several wealthy owners who added to the estate. By 1838, the house and grounds covered much of the area we now know as Abbeymead and Hucclecote. Eventually the house was sold with 48 acres of land to establish a private mental hospital. It is thought that this is when most of the landscaping was done with unusual tree varieties, many of which still exist today. Most of the mature trees are therefore now more than 150 years old. It is thought that comedian Spike Milligan,

Above: The new Robinswood Hill visitor centre and café, which also houses the HQ of the Gloucestershire Wildlife Trust. (Colin Organ)

Right: Wood sculptures at Robinswood Hill.

war poet Ivor Gurney and several other well-known people were inpatients of Barnwood House Hospital. The hospital gradually fell into decline and eventually closed in 1968. The majority of the land was sold off for development and many of the hospital buildings were demolished. Barnwood Park was formed from part of the remaining land. The central block of Barnwood House survived as a private residence until 2001 when it was demolished for development. At that time the rest of the land was given to Gloucester City Council.

Plock Court, on the site of a medieval manor house, is the city's largest area of grass sports pitches comprising 64 acres, to the north of the city at Longlevens. It is used by a number of teams to play formal sports such as football and cricket. It is also very popular for informal recreation such as dog walking, jogging and kite flying and has a relatively new wetland habitat. The Wotton Brook runs along the edge of the site. In recent times, it has become even more of a hub for sports, with all-weather multi-sports pitches, tennis courts and indoor facilities at the Oxstalls Tennis Centre (now renamed the Oxstalls Sports Park).

Above: Barnwood Park and Arboretum.

Left and opposite: Plock Court, one of Gloucester's largest public open spaces, combines informal green space with top-class sporting facilities.

Gloucester Park began life as part of the 'Spa Pleasure Grounds' created in 1815. By 1848, the land had been bought by the Gloucester Corporation and it was opened as a park. It was expanded to the current size of 30 acres in 1862.

The park was split when part of the Inner Relief Road, named Trier Way, was built through it in the 1980s, leaving a smaller separate area named Bakers Field with a skate park and former tennis courts. The park had a £1.2 million revamp in the early 2000s, with a new play area added and a Victorian-style bandstand, which replaced its brick and concrete predecessor. There are statues of Robert Raikes and Queen Anne. The park is used for a range of events, including the weekly ParkRun, Gloucestershire Pride and the summer funfair.

Hillfield Gardens is a public park on London Road housing several historical monuments – the chapel of a twelfth-century leper hospital, a seventeenth-century conduit house known as Scriven's Conduit, and the Kings Board, an eighteenth-century gazebo. It covers around 1.6 hectares and is supported by an active Friends group. The gardens were originally part of Hillfield House, which for many years was the County Council's Trading Standards office, but has recently been restored to a private house. The gardens were opened in 1933. The Friends group, which have looked after the gardens since 2005, obtained a £50,000 grant from the National Lottery in 2013. This money was used to create add a sensory garden and a woodland walk area. The gardens contain some of the oldest trees in Gloucester.

Alney Island lies to the west of the city centre in the middle of the River Severn and flooding has been at the core of its existence ever since the fifteenth

Above: The Victorian-style bandstand in Gloucester Park.

Below left: A statue of Sunday school founder Robert Raikes in Gloucester Park.

Below right: The Queen Anne statue by the Spa cricket ground in Gloucester Park has seen better days.

Above left and above right: The Scriven's Conduit and The King's Board in Hillfield Gardens, London Road.

century. The southern half of the island contains a 56-hectare nature reserve owned by the City Council containing wetland, meadow and woodland. In the northern half there is farmland where the famous Gloucester Cattle graze.

The area had the lowest river crossing point to Wales for centuries with bridges built by two of the most famous Victorian engineers, Isambard Kingdom Brunel and Thomas Telford. On both sides of the island is the River Severn, which has repeatedly resulted in flooding throughout its history. Legend has it that in 1016, feuding Danish King Canute and English King Edmund Ironside agreed to meet on Alney Island to settle their dispute.

Civic Life

Civic life is an important part of the character of Gloucester and has been for many centuries. The Mayor of Gloucester dates back to the charter granted to the city by Richard III in 1483. The position of Sheriff has its roots even further back – to the 1200s.

The royal charter of 1483 also made provision for twelve aldermen, two sheriffs, four stewards and twenty-two others to manage the affairs of the area. It also stated that the mayor should have a sword of state carried before him with two sergeants at mace to serve him.

The role of the mayor was different to today. They maintained civic property, presided at local courts and were responsible for the custody of prisoners. They were also responsible for seeing that weights and measures used in local commerce were correct, were steward and marshal of the King's household as far as Gloucester was concerned and were responsible for taking control of properties which were left without an heir.

These days, the mayor chairs meetings of the Full Council and represents the city at local and national events. Over the course of the year, the mayor, often with the sheriff and deputy mayor alongside them, attends several hundred events. Chris Chatterton, who was mayor in 2014, set the record by topping 1,000 events during his term of office.

The office of mayor is a ceremonial, non-political position. In 2002, an agreement was reached between the political groups on the City Council to rotate the nominations between them – allowing more people to serve as Gloucester's First Citizen. A referendum was held in 2001 on whether Gloucester should have an elected 'executive' mayor to run the city. The proposal was rejected by a margin of two to one, partly because of the esteem and affection in which the ceremonial office of Mayor of Gloucester is held.

Postmaster and Barton and Tredworth councillor Harjit Gill became the first Asian mayor of the city in 2007. Gloucester has applied on three occasions – 2002, 2012 and 2022 – for Lord Mayor status under a competition run for Queen Elizabeth II's jubilees, but has not been successful.

The mayor's chain office is of 18-carat gold, made up of a double row of a hundred horse-shoe links. The central link, which holds the badge, shows the

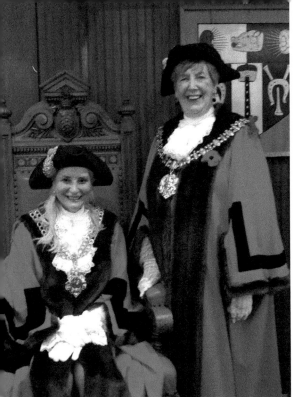

Above left: The Mayor and Sheriff of Gloucester 2021–22, Collette Finnegan and Pam Tracey.

Above right: The City of Gloucester crest proudly displayed at the North Warehouse in the Docks.

cap of maintenance in coloured enamel and the arms of the City of Gloucester in red enamel, and the city's motto 'Fides Invicta Triumphat' (Unconquered faith triumphs). The mayor's chain was purchased by subscription at a cost of £220 and presented to the Corporation in April 1870.

In 1932/3 the mayor of the day, W. L. Edwards, had the horseshoes reversed. They had been pointing downwards and he had them replaced pointing upwards. This reflects the modern idea that the luck of horseshoes is trapped in the bottom of the shoe. Theodore Hannam-Clarke became mayor the following year and remembered that his father had worn it with the shoes pointing down. After a year-long debate, which attracted national media attention, and the discovery that there had been no council approval for the action, the chain was restored to its original form.

In 2003, Mayor Pam Tracey was distressed to find one of the red enamel lions of the city crest had fallen off the pendant. After an article was published in *The Citizen* newspaper, it was found in the gutter outside the GL1 Leisure Centre. After being repaired, a replica pendant was created at a cost believed to be £8,000 and the original pendant is now safely located as part of the civic display cabinets at the City Council's North Warehouse building.

The ancient office of sheriff is perhaps the oldest of what are known as civic offices and usually many hundreds of years older than that of mayor. From 1066, towns and cities were administered for the king by a reeve. The term sheriff derives from Shire Reeve.

King John's charter of 1200 is the first to specifically give the right to have two bailiffs to perform the role of sheriffs. The sheriff presided over the local courts, held prisoners and collected fines and taxes. Most of these duties continued into modern times. The number of sheriffs was later reduced to one. They remained personally responsible for taxes until 1732 and summoned courts until 1974. These days it is purely a ceremonial position, but the City Council wanted to preserve the office of sheriff for historic reasons. The office of sheriff was combined with that of deputy mayor in the late 1980s.

The sheriff has two Sergeants-at-Mace to serve who join the mayor's macebearers in procession on formal occasions like Remembrance Sunday and the Annual Civic Service, carrying silver gilt maces which are 29 inches in length.

Fifteen towns and cities have retained the office of sheriff (Gloucester, Nottingham, Oxford, Southampton, Lincoln, Carmarthen, Haverfordwest, Berwick-upon-Tweed, York, Poole, Newcastle-upon-Tyne, Canterbury, Norwich, Lichfield and Chester). The National Association of City and Town Sheriffs of England and Wales was founded in Gloucester in 1985 by the then Sheriff of Gloucester, Councillor Andrew Gravells.

The sheriff's chain of office was presented to Henry Jeffs by his brother Freemasons when he was sheriff in 1883. Mr Jeffs gave the chain to the Corporation at the end of his term of office for the use of future sheriffs. The sheriff's chain is made of 18-carat gold and platinum and is very ornate, featuring the axe and mace, which are emblems of the sheriff's office, and the national emblems of the rose, shamrock and thistle.

The Assize of Ale

The sheriff's Assize of Ale, which often takes place as part of Heritage Weekend, raises funds for the city's civic charities, and dates back to medieval times when the sheriff was responsible for ensuring the ale on sale in the city was of palatable quality.

The sheriff, together with an army of followers dressed in medieval clothing, tour the pubs in the city's historic core collecting cash for charity and carrying out a slightly bizarre ritual involving a wooden stool, someone dressed in leather breeches and an egg timer. The sheriff has an 'Ale Conner', whose job it is to sit on a wooden stool, on which a small amount of ale has been poured, wearing a pair of leather trousers.

If after three minutes the trousers stick to the stool, the ale does not pass the test. Conversely if the Ale Conner can move freely at the end of the three minutes, it

The Sheriff's Assize of Ale, involving Ale Conner Jim Higgs and Town Crier Alan Myatt, is one of Gloucester's quirky traditions.

does pass. The tradition was reintroduced in 2003 by the author during his year as Sheriff of Gloucester and has taken place in each year since. The author continues to organise the event with Town Crier Alan Myatt, with a host of city councillors and other local 'characters' taking part. The event has raised over £15,000 for the civic charities since it was introduced.

Mock Mayor of Barton

The Mayor of Barton is a 'mock' mayor, one of only a few remaining in England. It all started when Charles II returned to the throne. He didn't like Gloucester very much, because of what happened in the Civil War. After the Restoration, Charles took his revenge in various ways, knocking down the city walls, and severely reducing the city boundaries. This left the Barton area outside the city. The residents were not amused and decided that if they couldn't defer to the Mayor of Gloucester, then they'd invent their own, simply to poke fun at Gloucester's official powers-that-be. The tradition was revived by a group of local people, led by shopkeeper Jean George, in the mid-1980s and is now combined with Gloucester Day, which celebrates the lifting of the siege.

A procession leads the mock mayor, usually travelling in a whacky form of transport, to meet the real mayor, where gifts (and sometimes the odd jibe) are exchanged. During the year, the Mock Mayor of Barton is asked to present prizes, open events and generally work on behalf of the community.

A statue of King Charles II tucked away by a block of flats, perhaps as a way of Gloucester expressing its displeasure at the King knocking down the city walls in 1662.

The Lamprey Pie

Gloucester has been presenting a lamprey pie to the reigning monarch since the medieval era. By 1200 it had become customary for the city of Gloucester to send the English monarch a pie each year, and King John fined the city 40 marks or £26 13s 4d (equivalent to £38,000 in 2020) for failing to send a pie at Christmas. The custom of Gloucester sending the monarch a lamprey pie, decorated with gilded ornaments, at Christmas ended in 1836 when it was considered too expensive.

Lampreys were considered a delicacy and were popular with royalty. Henry I is said to have died after eating 'a surfeit of lampreys'. The lamprey pie also features in the television drama *Game of Thrones*.

The number of lampreys in English rivers declined in the nineteenth century and is said to have vanished from the upper reaches of the Severn by the middle of the century. It is now a protected species.

A lamprey pie is still presented by Gloucester to the monarch on special occasions. A 20-lb pie was presented at the 1953 Coronation of Elizabeth II. The pie was made by the School of Cookery at RAF Innsworth, using lampreys from the River Severn, caught by Cadogan Bros of Awre and stored in the deep freezer of J W Rigby & Sons at Eastgate Market. A pie was also presented at the Silver Jubilee in 1977. By the time of the 2002 Golden Jubilee no British lampreys could be sourced, and lampreys from the Great Lakes in Canada have been used for this and several subsequent occasions.

By the time of Queen Elizabeth II's Golden Jubilee in 2022, in light of the climate emergency, it was felt unsustainable to fly lampreys from the other side of the world. It was also felt that it wouldn't be right at a time of a cost of living crisis to make a pie that wouldn't be eaten. Instead, lampreys were represented in specially coloured pastry on the crust of a pie filled with a historic Gloucestershire

A variation on the traditional lamprey pie being presented to Lord Lieutenant Edward Gillespie OBE for Queen Elizabeth II's Platinum Jubilee.

Pie recipe based on Old Spot pork and apple. The pie was made by the chefs at the Farmers Boy Inn at Longhope, just outside Gloucester, and presented to the county's Lord Lieutenant Edward Gillespie OBE at Llanthony Secunda Priory. This venue was chosen because records show that in 1530 the Prior of Llanthony sent 'cheese, carp and baked lampreys' to King Henry VIII at Windsor. With the agreement of the royal household, the Lord Lieutenant agreed to pass the pie on to 'Gloucester Feed The Hungry', who used it to help those in need. A similar approach was taken for the Coronation of King Charles III in May 2023.

Other Civic Activities

In 2016, the Resident Judge at Gloucester Crown Court was appointed Honorary Recorder of Gloucester – both to strengthen the city's standing in the criminal justice system but also to enhance the civic link with the city.

Individuals who have made important contributions to the city have been admitted as Honorary Freemen, including Gloucester's Rugby World Cup-winning trio Phil Vickery, Trevor Woodman and Andy Gomarsall. Alan Myatt, Gloucester's much-loved world record-holding town crier, who is seen as an iconic figure in the city, was another recipient. More recently, Dame Janet Trotter was made the first Freewoman not only for her role as former Lord Lieutenant for Gloucestershire, but for her charity work and significant contributions to both the NHS and education in the county. The mayor is also able to nominate individuals who have made an outstanding contribution to receive the Mayor's Medal.

Gloucester is twinned with Gouda in The Netherlands, Metz in France, Trier in Germany and St Ann in Jamaica.

Military Connections

The city isn't afraid to show its pride in the military, whether that is by turning out in great numbers on Remembrance Sunday and Armed Forces Day or by bestowing civic honours. Freedom of the City was conferred upon the Royal Gloucestershire, Berkshire and Wiltshire Regiment in 1995, and subsequently transferred to its successor regiment The Rifles in 2009. More recently in 2019 this honour has been granted to NATO's Allied Rapid Reaction Corps (ARRC), based at nearby Imjin Barracks, Innsworth.

Freedom of the City was also granted to HMS *Gloucester* in 1988. In all, there have been ten HMS *Gloucester*s and it was a sad day for the city when the linking of the city with a Royal Navy ship ended in 2011 when the final HMS *Gloucester* was decommissioned. The crew exercised their Freedom to march through the city, with the Duke and Duchess of Gloucester in attendance, in May 2011 before handing a silver casket containing the Freedom back to the mayor.

The first HMS *Gloucester* was wrecked in 1682 on a sandbar off Norfolk while carrying the Duke of York (the future James II). The wreck was rediscovered in 2007, although the discovery was only made public in 2022, the delay being to allow protected investigation of the site, which is in international waters.

The HMS *Gloucester* built in 1937 was sunk by German dive bombers on 22 May 1941 during the Battle of Crete with the loss of 722 men out of a crew of 807. The ship acquired the nickname 'The Fighting G' after earning five battle honours in less than a year.

The last HMS *Gloucester* returned to Portsmouth for the final time on 24 May 2011 and was decommissioned on 30 June 2011, under the command of her last captain, Commander David George. On 22 September 2015, she left Portsmouth harbour under tow, bound for a breaker's yard in Turkey. During her service she sailed 787,928 miles.

On decommissioning, Commander David George, said, 'I cannot express how proud I am of the ship. It was a very emotional final entry for the very best of ships, but she is twenty-nine years old, and with more than 750,000 miles under her belt. Gloucester's time has come to bow out with dignity.'

Several pieces of memorabilia from the ship were presented to the City Council, including the ship's bell, and are held either at the North Warehouse in the docks or as part of the Museum of Gloucester's collection. The bell from an earlier HMS *Gloucester* is fixed to one of the beams in the Council Chamber at North Warehouse.

The city has a special relationship with the city of Paju in South Korea by virtue of its proximity to the site of the Imjin River, where the Gloucestershire Regiment fought with distinction during the Korean War, from 22 to 25 April 1951.

They fought a force of over 10,000 Chinese regular troops. Towards the end of the battle, the Glosters were completely surrounded and running out of ammunition. Against overwhelming odds, the Glosters held the line against the Chinese for four days. The Glosters' actions in delaying the Chinese allowed the rest of the United Nations forces time to regroup and block the advance of the enemy towards the South Korean capital Seoul.

For their heroic stand during the Battle of the Imjin River, Korea, April 1951, the Glosters were awarded the Presidential Unit Citation, the highest American award for collective gallantry in battle, by US President Harry Truman. In Korea, the hill that the Glosters made their final stand on was renamed as 'Gloster Hill' and the corresponding valley renamed Gloster Valley.

In 2014, the then Mayor of Gloucester, Chris Chatterton, visited the Korean city to attend the unveiling of a new multi-million-pound monument in honour of those who lost their lives in the Battle of Imjin River. The monument features the regiment's beret, with its 'Back Badge' which was granted to the regiment after another act of gallantry in fighting back to back at the Battle of Alexandria in 1801. A footbridge near Paju, named the 'Gloucester Heroes Bridge', was opened

in October 2016. For its part, Gloucester has named the walkway alongside the Victoria Basin at Gloucester Docks 'Paju Walk'.

More recently, an extensive programme of activities took place to commemorate the seventieth anniversary of the battle, with Korean dignitaries visiting Gloucester, in the presence of the Duke of Gloucester in September 2021.

A walkway alongside the Victoria Basin at Gloucester Docks has been named 'Paju Walk' in honour of Gloucester's links with the City of Paju in South Korea.

Royal Connections

Gloucester has been granted several royal charters. Henry II granted Gloucester its first charter in 1155, which gave the burgesses the same liberties as the citizens of London and Winchester. A second charter of Henry II gave them freedom of passage on the River Severn. The first charter was confirmed in 1194 by King Richard I. The privileges of the borough were greatly extended by the charter of King John (1200), which gave Gloucester two 'reeves' or 'bailiffs'.

Richard III's charter of 1483 is discussed in the previous chapter as granting the position of mayor and burgesses. Further charters were granted by Elizabeth I in 1580, Charles I in 1626/7, Charles II in 1672 and most recently by Elizabeth II on local government reorganisation in 1974.

King Lucius

A local legend, first recorded in the eighteenth century, has it that the church on the site of St Mary de Lode in Archdeacon Street, just outside the cathedral

St Mary de Lode Church, just outside the cathedral precincts, is the oldest parish church in the city and believed to be the burial place of King Lucius.

precincts, was the burial place of King Lucius, the first Christian king of Britain. He was said to have established the rank of Bishop in Gloucester in the second century AD. Combined with the results of the archaeological work, this inspired the belief that the church was built on the site of an ancient Roman temple, and was the first Christian church in Britain. An effigy of him can be found in the chancel of the church.

Alfred the Great

A Royal Mint in Westgate Street was first recorded in the reign of Alfred the Great (871–899). The mint issued silver pennies stamped with the image of the King. It was probably shut down when King Edward I reformed England's coinage and reorganised its mints in 1279. A coin from the reign of William the Conqueror (1066–87) was found in a field in Highnam, just outside Gloucester, by metal detectorist Maureen Jones in November 2011. The coin, which dates from 1077–80, features the name of the moneyer Silacwine and where it was minted. The City Council acquired it for £2,000.

Edward the Confessor

During King Edward's time, the Christmas period was usually spent at Gloucester. Edward was a keen sporting huntsman. Since the Forest of Dean was his favourite hunting ground, it seemed natural that after a good autumn's hunting, he would spend Christmas at King's Holme in Gloucester.

William the Conqueror

In the early winter of 1085, William I of England, also known as William the Conqueror, held his Christmas 'King's Court' at Gloucester. It was there that he announced his plans for a survey of the English possessions he had conquered in 1066, which became known as the 'Domesday Book'.

Robert, Duke of Normandy

Robert Curthose, Duke of Normandy, was the eldest son of William the Conqueror. After a failed attempt to seize the English crown from his younger brother, Henry I, he was imprisoned, first at Devizes Castle and then Cardiff. He died in 1134 and was buried in the abbey church of St Peter, now Gloucester Cathedral. His effigy, made of painted oak and under an iron framework, is thought to be from the thirteenth century but rests on a fifteenth-century chest tomb.

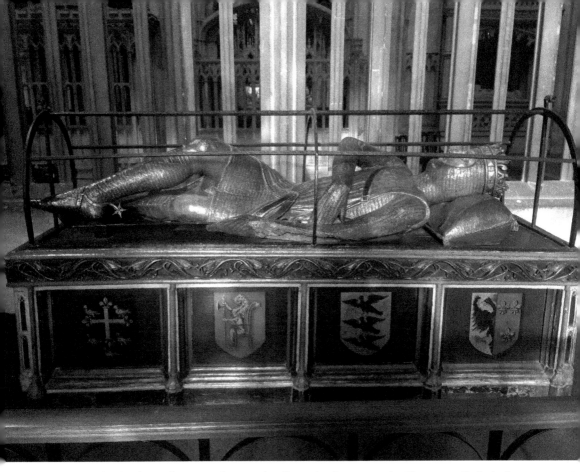

The tomb of Robert of Normandy, son of William the Conqueror, in Gloucester Cathedral.

Edward II

After being captured in Llantrisant in Wales and moved to Berkeley Castle, Edward II was deposed and, despite two attempts to rescue him, was announced as dead in September 1327. It has never been totally clear how he died but legend has it that a red-hot poker was inserted somewhere rather painful. Some people say that his screams could be heard for five miles around the castle. It doesn't bear thinking about!

Edward's body was then taken to Gloucester Abbey on 21 October, and on 20 December he was buried by the high altar, the funeral having probably been delayed to allow Edward III to attend in person. Gloucester was probably chosen because other abbeys had refused or been forbidden to take the king's body, and because it was close to Berkeley. The funeral was said to have been a grand affair.

Edward II's tomb rapidly became a popular site for visitors, probably encouraged by the local monks, who lacked an existing pilgrimage attraction. Visitors donated extensively to the abbey, allowing the monks to rebuild much of the surrounding church, which by 1470 started to resemble the cathedral we see today, and brought great wealth to the city. The tomb was restored in 2007–8 at a cost of £100,000.

The tomb of King Edward II at Gloucester Cathedral.

Henry III

Henry was staying safely at Corfe Castle in Dorset with his mother when his father, King John, a weak monarch known as 'Lackland', died. On his deathbed, John appointed a council of thirteen executors to help Henry reclaim the kingdom and requested that his son be placed into the guardianship of William Marshal, one of the most famous knights in England. The loyalist leaders decided to crown Henry immediately to reinforce his claim to the throne. London was held by the rebellious barons and Prince Louis, so the traditional place of coronation, Westminster Abbey, couldn't be used. Cardinal Guala Bicchieri, the Pope's representative in England, then oversaw his coronation at Gloucester Cathedral on 28 October 1216. In the absence of the Archbishops of Canterbury and York, he was anointed by Sylvester, Bishop of Worcester, and Simon, Bishop of Exeter, and crowned by the Bishop of Winchester, Peter des Roches. The royal crown had been either lost or sold during the civil war, so instead the ceremony used a simple gold band belonging to his mother, Queen Isabella. The event in 1216 was the last time an English or British monarch was crowned outside of London. Henry later underwent a second coronation at Westminster Abbey on 17 May 1220 (then St Peter's Abbey).

Henry was deeply religious and granted the use of oak trees from the Royal Forest of Dean to build Blackfriars and Greyfriars.

In 2016, the city of Gloucester celebrated the 800th anniversary of the coronation of Henry III with a re-enactment of his enthronement in Gloucester Cathedral. A Gloucester schoolboy was chosen to be 'King for a Day'. Eleven-year-old Fraser Martin, who won the 'Search for a King' competition, played the role of Henry III. A re-enactment of the coronation parade processed through the city centre in which the 'King' was carried aloft on a ceremonial chair from Blackfriars Priory to the cathedral. The re-enactment was presided over by the Right Reverend Rachel Treweek, Bishop of Gloucester.

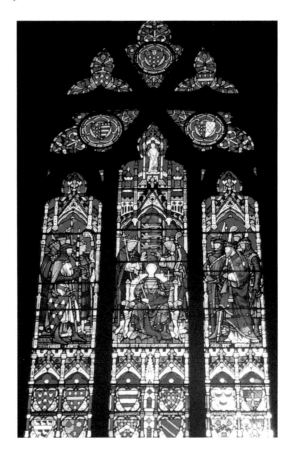

This window at Gloucester
Cathedral commemorates the
coronation of Henry III.

Richard III

Richard III's reign was a notable one to the city, as he granted the charter on which
our local government is mainly based. It gave the right, among other things, to a
mayor, with an accompanying sword and cap of maintenance, and mace-bearers
in procession, which were rare privileges even for an ancient city. Gloucester was
increased to 45 square miles, but most of this area was taken away later. He is
said to have planned and ordered the murder of the Princes in the Tower while in
Gloucester.

After Richard III's body was discovered underneath a car park in Leicester,
a petition was launched to have him buried in Gloucester. He was the Duke of
Gloucester, although historians say he didn't come here very often. York also
staked a rival claim. Some felt that it was unseemly to be arguing over the bones of
a long-deceased monarch. The petition gathered only fifty-two signatures.

In 2014, Mayor Chris Chatterton welcomed the Duke of Gloucester to the City
Museum for the Richard III exhibition and took great pride in showing him a
facial reconstruction of the king, created by the University of Dundee, and saying,
'Prince Richard, Duke of Gloucester, meet Prince Richard, Duke of Gloucester.'

Henry VIII and Elizabeth I

Henry VIII is said to have visited in August 1535, lodging at the then Gloucester Abbey and going hunting at Painswick. He also founded The King's School in 1541 by a direct royal proclamation. His daughter, Queen Elizabeth I, is said to have visited in August 1574. She granted port status to Gloucester in 1580, the most inland in the country, opening up trade links with the rest of the world.

Queen Elizabeth II

Queen Elizabeth visited Gloucester on a number of occasions during her long reign, including visiting the Guildhall in 1955 to mark the 400th anniversary of the city's charter of liberties from Henry II. In April 1986, she opened Widden School and attended a service of thanksgiving for the life of the late Duke of Beaufort, who was Lord High Steward of Gloucester, at the cathedral.

In April 2003, the Queen and Duke of Edinburgh visited Gloucester Cathedral for the Maundy Service – handing out traditional 'Maundy Money' to deserving local people. It was a memorable day for me. As Sheriff of Gloucester at the time, I had the honour of taking the Duke of Edinburgh on 'walkabout' in Westgate Street. Even more memorably, a visiting steward took me to the wrong seat and, much to Her Majesty's amusement, the Lord Lieutenant (her representative in the county) didn't have anywhere to sit – until he politely asked me to move!

Queen Elizabeth II on a visit to Gloucester Docks in 2009. (Gloucester City Council)

The Queen and Duke visited again in October 2009 to see the progress of regeneration at Gloucester Quays. They didn't venture inside the newly built outlet shopping centre because of fears the monarch might slip on the shiny new granite flooring. Instead, the Queen and Duke came up the canal on a Royal Navy boat each, going as far as the historic docks to wave at the crowds before turning around and disembarking near Llanthony Priory and having lunch at the new Gloucestershire College campus. It is said that when Her Majesty was travelling up the canal, she looked over at the derelict warehouses at Bakers Quay and commented, 'So you've still got some work to do then!'

The Duke of Gloucester

The title of Duke of Gloucester was first created in 1385 and has had two gaps of more than 150 years when it wasn't in use – between 1485 and 1659 and between 1751 and 1928. Today's Duke and Duchess of Gloucester are regular visitors to the city and take a close interest in what happens here. The Duke opened Back Badge Square in the docks and the offices of Roberts Limbrick architects in the Old Carriage Building in Bruton Way in 2011. He also presented Gloucester Civic Trust with The Queen's Award for Voluntary Service in 2013. During the Covid-19 pandemic, the Duke and Duchess sent a message of support to the people of the city, which was published on the royal website and social media channels. As well as thanking key workers, they to encouraged residents to 'strive to revive the life and livelihood of the city as soon as possible'.

Back Badge Square in the docks, named in honour of the Gloucestershire Regiment.

In September 2022, the Duke and Duchess accepted an invitation to attend the Gloucester Day celebrations in the city. Given that Gloucester Day commemorates the lifting of the Siege of Gloucester in the Civil War, when the Parliamentarian troops resisted the much larger Royalist army, having a member of the royal family join in the fun is quite something! It was nearly 380 years ago and I like to think we've all moved on since then, but it was still a significant event.

Gloucester Castle

The original Gloucester Castle was built during the reign of William the Conqueror and was rebuilt before 1113 by Walter of Gloucester overlooking the River Severn. Henry III often used it as a residence. It ceased to be maintained as a fortress under Richard III but was used as the official county gaol. Stonework was taken from the castle to be used in new roads and buildings. Most of the buildings on the site had gone by the seventeenth century. What remained of the castle was demolished in 1787 and a new gaol was built by 1791.

More improvements and some repairs were carried out by Henry III, these improvements including a bridge across the River Severn leading to a barbican in the outer wall. Henry III often used it as a residence, and it played an important role in the barons' war when it was besieged twice in 1264–5.

Royal City Status

In 2017, Gloucester held a public consultation on whether it should petition for 'Royal City' status on the basis of its many royal connections. There is no application process to gain this status; it is a matter of petitioning government ministers who would make a recommendation to the Queen.

The suggestion, which was initially made on social media, was a controversial one – largely because of the city's role in supporting the Parliamentarian cause against the Royalist army in the Siege of Gloucester in the English Civil War. Others felt there were more important issues to deal with.

Despite residents backing the idea by a majority of 60 per cent to 40 per cent, as leader of Gloucester City Council at the time, I felt that it wasn't a strong enough mandate to proceed. To stand a chance of success, I believed it needed a strong majority of the city behind the idea.

Gloucester's Communities

Since its origins when the local tribesman co-operated and formed a community with their Roman visitors, Gloucester has been a meeting place and focal point for people. Its special strategic location has long made it a crossroads where north, south, east and west have come together. People from all over the world have been visiting and settling in Gloucester for centuries. There is evidence of a Jewish community as early as 1158–59 and the right for Jews to live in Gloucester was expressly confirmed during the reign of Henry III. They lived around present-day Eastgate Street and had a synagogue on the north side.

Gloucester's tradition of warmth and hospitality is noted by visitors and residents and forms the foundation for the successful multi-cultural city that exists today. Throughout its history Gloucester has welcomed a diverse population and today over 200 different languages and dialects are spoken in the city. It has provided a haven for migrants from Eastern Europe and refugees. Gloucester embraces its diversity and enjoys good community relations, but never takes this for granted. Gloucester has significant and active communities of Irish, Indian, Chinese, Jamaican, Ukrainian and Polish descent, to name just a few.

Gloucester is the most ethnically diverse place in the county, with 15 per cent of the population from an ethnic minority background. This is lower than the UK average of 18 per cent and much lower than Bristol (28 per cent), Birmingham (51 per cent) and London (63 per cent) – but the ethnic minority population is concentrated in the Barton & Tredworth ward, where it makes up over 40 per cent of the total. Barton & Tredworth is a vibrant part of the city, where the international nature of shops, supermarkets and takeaways reflect the cultural diversity of the area.

Gloucester Muslim Welfare Association was established in the early 1960s, following the arrival of the first generation of Muslims in the city of Gloucester and was responsible for finding somewhere for the community to come together. Initially this was at members' houses or in halls, clubs or schools. For the first year, on the festival of Eid the community worshipped in Gloucester Park.

A pair of semi-detached houses in Ryecroft Street became the community's permanent home before being demolished to make way for the first ever purpose-built mosque in the south-west of England and Wales.

Above left and above right: The Jama-Al-Karim mosque in All Saints Road and the Masjid-E-Noor mosque in Ryecroft Street.

The local community fund-raised to build it, with donations coming from Panama, South Africa, Barbados, Canada, and United Arab Emirates and a generous donation from a sheikh in Kuwait. The mosque was successfully unveiled in 1983 and became a landmark representing the emerging Muslim community.

The association went on to set up the Gloucestershire Islamic Secondary School for Girls in the old Widden School buildings and a nursery and an Islamic Primary School at the Al-Ashraf Cultural Centre in the former Priestley Studios building in Stratton Road.

A second purpose-built mosque, 'Jamia Al Karim', in All Saints Road opened in 1985 following the demolition of a warehouse where Muslims had been worshipping for a number of years. The new mosque was built in the Eastern style with a minaret and dome. In more recent years, mosques have been created in Conduit Street and Charles Street.

Gloucester's Polish community has its roots in the Second World War resettlement camps which existed in the county. A further wave of immigration took place during the communist rule of the 1970s and 1980s and again when

Poland joined the EU in 2004, although the numbers have declined since the UK left the EU.

A Polish School was established in 2007 and ran for a number of years. After a gap of around five years it reopened at Milestone School in 2018 before moving to Kingsway Primary School after the Covid-19 pandemic. The Polish Heritage Day event was started in 2017 by Jaro Kubasczcyk and was the first event to take place in the new Kings Square in 2022.

There has been a Ukrainian Club in Midland Road in the city for many years and in 1974 the community bought the Church of the Good Shepherd in Derby Road. This became a focus for humanitarian relief after Russia's invasion of Ukraine in 2022. Gloucester people turned out in large numbers at the docks after the invasion to show their solidarity with the Ukrainian community.

Gloucester's MP, Richard Graham, told Parliament in April 2018 that the city has around 3,800 residents of Afro-Caribbean heritage, many of whom arrived as part of the 'Windrush generation', named after the first ship which brought workers from Jamaica, Trinidad and Tobago, between 1948 and 1971. Mr Graham said, 'They came to work, many at the specific request of the British government, particularly in the NHS, and have made an enormous contribution to our city.'

They tended to settle in the Barton and Tredworth area where the large Victorian houses had many rooms to rent. The first club for West Indians was in the Old Custom House on The Quay. Jamaican Independence Day is celebrated with an event in Gloucester Park every year in August.

The Irish community comes together at the Gloucester and District Irish Club in Horton Road, which is used for a variety of events and activities. The first meeting of the Gloucester Irish Club Committee took place at St Peter's Junior School in February 1964 to organise and raise funds to set up a club. The first club opened in Station Approach on Easter Sunday 1969. British Rail needed the club to leave in early 1975 to build a new station, so the club moved to its current base in Horton Road which belonged to the GR Lane health products business and prior to that was the Gloucester Pin Factory.

The Gloucestershire Chinese Women's Guild was awarded the Queen's Award for Voluntary Service in 2003 and the late Mew Ning Chan, its chairperson, was featured in Her Majesty's Christmas Day message that year, receiving the award.

Another important community is the travelling showpeople at Pool Meadow. They spend much of the year out on the road, taking their rides and other attractions to funfairs up and down the country. Many of the families here have been in Gloucester for many generations and are well-known both in the city and in the fairground world.

Gloucester is also a focus for the county's LGBT community, with the annual Pride event parading through the city centre streets en route to Gloucester Park, where there are performances, stalls and fairground rides.

Gloucester's community spirit was shown during the floods of July 2007, when over 1,000 homes in the city were flooded. In addition, the water supply was lost

for a total of seventeen days and a big operation, involving numerous volunteers as well as the military and emergency services, ensured water got to everyone who needed it, particularly the vulnerable. This spirit was shown again during the Covid-19 pandemic when communities, working alongside the City Council and other agencies, supported their neighbours who needed help with collecting prescriptions, walking dogs, and buying essential food.

Community spirit in Gloucester can sometimes be generated in unexpected ways. In 2018, Tash Frootko, a local landlord, inspired residents in a row of terraces in the city centre to paint their houses in bright colours. This lifted their spirits and prompted conversations with neighbours they had not spoken to before. The exercise has been repeated in two other streets – St Mark Street and Sebert Street – just outside the city centre in Kingsholm, with similar results.

The 2021 elections saw the first councillors of Polish, Bangladeshi and Filipino origin elected to the council. The city has led the way in diversity terms, with the appointment in 2015 of the Right Reverend Rachel Treweek as Bishop of Gloucester – the first woman Diocesan Bishop in the country.

Above and opposite: The 'Rainbow Square' at St Kilda Parade/Station Road/Nettleton Road in the city centre. (Tash Frootko)

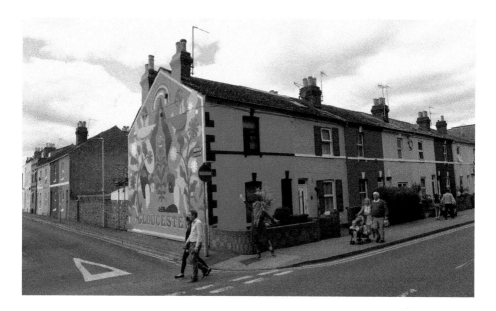

Most of Gloucester's growth in recent decades has been in the suburbs like Abbeydale, Abbeymead and Quedgeley, but in more recent times there have been efforts to bring more people to live in the city centre – both to help the city centre economy, to regenerate run-down sites and buildings and to relieve pressure on greenfield sites. The Greyfriars scheme on the former Gloscat college site is a good example, delivering around 300 homes. Gloucester Docks is perhaps the most popular place to live close to the city centre, where penthouse apartments can sell for over £300,000. Brunswick Square, with its elegant Regency townhouses and private gardens to the centre, is also seen as desirable place to live.

Property in Gloucester is good value, with prices around 30 per cent cheaper than Cheltenham at 2022 prices, according to property website Zoopla. Gloucester has many attractive houses, but only six fall into the top council tax band, Band H. This is for properties valued at over £320,000 as of 1991 – around £1.7 million as of 2022. This compares with 124 in Cheltenham and 722 in the Cotswold District. The most expensive house to come to the market in recent times was the eight-bed Hillfield House on Denmark Road, which has twenty-three rooms, including a 'Tower Room', and several stained-glass windows. It was the former offices of the County Council's Trading Standards department before being painstakingly restored to a family home by its previous owners. It came onto the market for £1.85 million in 2020 and sold for £1.5 million, according to Land Registry records.

Gloucester does have some areas of disadvantage, including some parts around the edges of the city centre and Barton & Tredworth, as well as in suburbs like Matson and Podsmead. This doesn't stop them from having some of the strongest communities anywhere in the city. Gloucester's council housing stock was transferred to Gloucester City Homes in 2015 after receiving a £40 million upgrade.

Above: The Greyfriars development on the former Gloscat college campus in Brunswick Road.

Left: Brunswick Square is a popular place to live, with a private garden to the centre.

Gloucester has a huge number of voluntary and community groups covering many aspects of city life – from the Friendship Café and the City Farm in Barton & Tredworth, to the Redwell Centre in Matson, the Friends of Saintbridge Pond and Gloucester Feed the Hungry, to name just a few. Almost every mayor of the city remarks how surprised they are at just how much work is done by volunteers in Gloucester and how the city just couldn't function without them. The history of a place, its buildings, its open spaces and its facilities are all important, but ultimately it is the people who make Gloucester the place it is today.